Mount Rainier National Park

AN ARTIST'S TOUR — MOLLY HASHIMOTO

SKIPSTONE

Published by Skipstone, an imprint of Mountaineers Books—an independent, nonprofit publisher

Skipstone and its colophon are registered trademarks of The Mountaineers organization.

Printed in China

24 23 22 21 1 2 3 4 5

Lines from "Water" on page 103 published in *The Whitsun Weddings* by Philip Larkin quoted with permission of the publisher, Faber & Faber, Ltd.

Copyeditor: Ellen Wheat
Design: Kate Basart/Union Pageworks
Cover: *Tipsoo Lake and Mount Rainier* Frontispiece: *White-tailed ptarmigan* Page 130, top: *Tiger lily; bottom: Lorquin's admiral* Page 132: *Mount Rainier from Norse Peak* Page 134: *Steller's jay* Page 136: *Sooty grouse*

Library of Congress Cataloging-in-Publication data for this title is available at https://lccn.loc.gov/2021008631

Printed on FSC®-certified materials

ISBN: 978-1-68051-334-9

MIX
Paper from
responsible sources
FSC® C008047
www.fsc.org

Skipstone books may be purchased for corporate, educational, or other promotional sales, and our authors are available for a wide range of events. For information on special discounts or booking an author, contact our customer service at 800-553-4453 or mbooks@mountaineersbooks.org.

Skipstone
1001 SW Klickitat Way
Suite 201
Seattle, Washington 98134
206.223.6303
www.skipstonebooks.org
www.mountaineersbooks.org

LIVE LIFE. MAKE RIPPLES.

Mount Rainier National Park

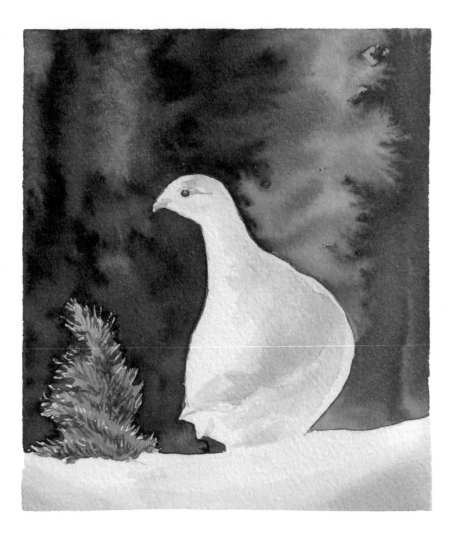

To my family & friends

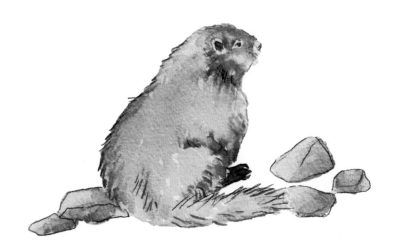

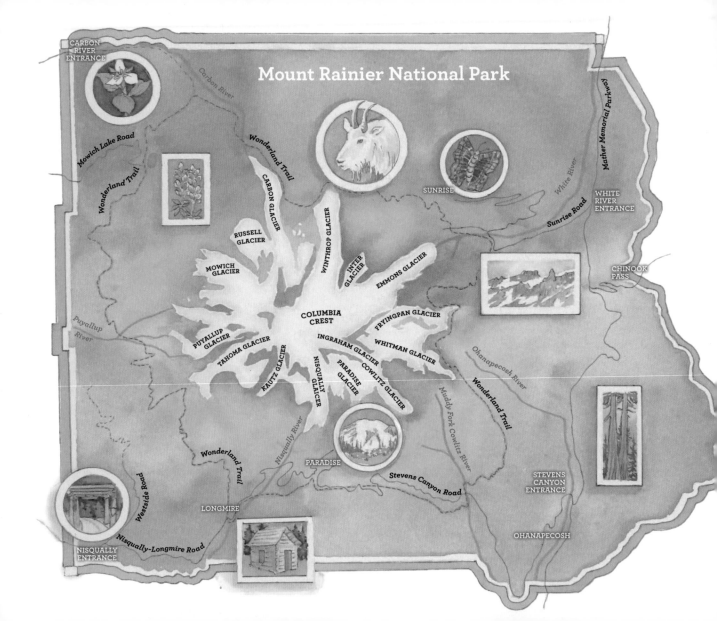

Mount Rainier National Park

CARBON RIVER ENTRANCE

Mowich Lake Road

Carbon River

Wonderland Trail

Wonderland Trail

CARBON GLACIER

RUSSELL GLACIER

MOWICH GLACIER

WINTHROP GLACIER

INTER GLACIER

EMMONS GLACIER

SUNRISE

Sunrise Road

White River

Mather Memorial Parkway

WHITE RIVER ENTRANCE

CHINOOK PASS

Puyallup River

PUYALLUP GLACIER

TAHOMA GLACIER

KAUTZ GLACIER

NISQUALLY GLACIER

COLUMBIA CREST

INGRAHAM GLACIER

PARADISE GLACIER

COWLITZ GLACIER

WHITMAN GLACIER

FRYINGPAN GLACIER

Ohanapecosh River

Wonderland Trail

Muddy Fork Cowlitz River

Wonderland Trail

Nisqually River

PARADISE

Stevens Canyon Road

STEVENS CANYON ENTRANCE

Westside Road

Wonderland Trail

LONGMIRE

NISQUALLY ENTRANCE

Nisqually-Longmire Road

OHANAPECOSH

Contents

Introduction: A Mount Rainier Pilgrimage 9

Nisqually Entrance & Longmire 31

Paradise 46

Stevens Canyon 60

Ohanapecosh 70

The White River & Sunrise 78

Carbon River & Mowich 99

Wildflowers 114

Acknowledgments 127

Resources 129

Further Reading 130

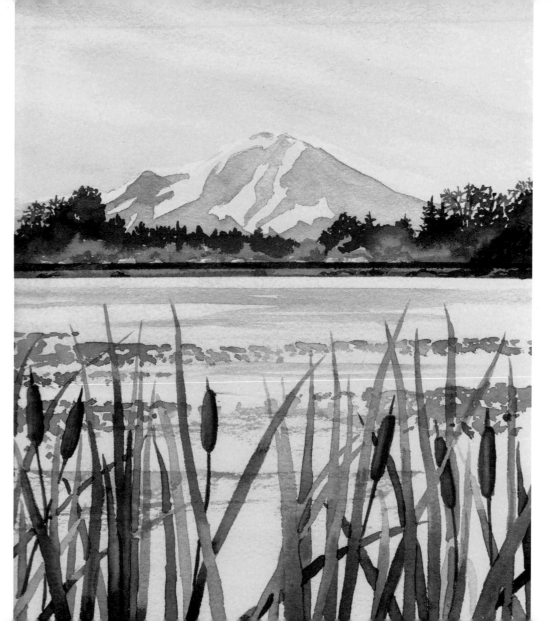

Introduction: A Mount Rainier Pilgrimage

I rise and all the aging years are
* backward flung*

For soil up here and flower and even
* time are young.*

—EDMOND S. MEANY, *Seattle Post-Intelligencer*, 1915

I've been visiting mountains ever since my childhood years in Denver. Family picnics and road trips to the Rockies ignited my early love. My father was in the military, so we moved a lot and didn't always live near mountains. But while in high school in Minnesota I decided that I was going to live in Seattle someday. I didn't know anyone there and had never visited; it must have been the unforgettable image on the 1962 Seattle World's Fair posters of the Space Needle with Mount Rainier as a backdrop that enticed me.

I moved to Seattle after college, and Mount Rainier became my favorite destination. These trips over many decades have been a lifelong pilgrimage, a Pacific Northwest version of El Camino de Santiago in Spain, or the Hajj to Mecca, or Buddhist

Mount Rainier from Union Bay, Seattle

treks to Himalayan shrines. My pilgrim journey has had different phases. In my twenties I often hiked up to Camp Muir, a climber's base camp at 10,076 feet. Friends and I would drive from Seattle, leaving at about three o'clock in the morning to beat rush hour in Puyallup. Summer dawn broke to the east behind Rainier, its pale and impossibly huge silhouette imprinted on the violet sky. Sometimes we'd arrive at the Paradise parking area to find the mountain and the visitor center shrouded in thick fog. Many times after hiking an hour, we would emerge from the fog just above Panorama Point and look back down on an ocean of clouds.

During that same adventurous and energetic phase, I telemark-skied down from Camp Muir on the Muir Snowfield and managed to keep my balance all 4,800 feet or so down to Paradise. This was in the days before backcountry skis came with edges, and so I recall the feat as one of my life's peak moments. I had never before thought of myself as much of an athlete.

I discovered while climbing Pinnacle Peak in the park's Tatoosh Range that technical climbing was not for me. My imagination got the better

of me, and I wasn't able to suspend the fear that attended vertical exposure. I would wait and watch below while my climbing friends roped up and ascended peaks. I would sit for hours looking at the scenery, absorbing it. When I got home I would try painting some of those alpine views. It seemed inadequate to just have the experiences. I had to document them, memorialize them. Those days spent sitting and observing the mountain led me to one of my fundamental beliefs about art: To draw and paint and write, you don't just make things appear out of your imagination. You really have to spend a great deal of time looking. More than anything else, art is about paying attention.

After I married, I traveled more often to the Sunrise area, in the northeast section of the park, a shorter drive from Seattle. I even went the day before our son was born. Looking back on that now, I can't believe I took such a risk; I think I wanted to introduce him to the mountain because it was such an important part of my life. And maybe I was aware that I would soon be unable to drive to Rainier whenever I felt like it. Yet we often took our children hiking there when they were small. And later we hiked with our teenage daughter (not the happiest of campers) to Burroughs Mountain above Sunrise,

where she forgot all her teenage angst when we spotted a mountain goat nanny and her kid.

Paintings, the Pilgrim Badges

I've been drawing and painting the mountain as long as I've been traveling to it. It's a way of freezing time and keeping the experiences alive. When you come home after a trip, there can be a real letdown if you don't draw and paint what you've seen, looking things up and re-living it. Maxine Greene, educational philosopher and social activist, noted how important it is for people to "plunge into subject matter in order to steep themselves in it. . . . There must be an answering activity if we are to perceive what presents itself to us; we must reach out toward the object . . . through an act of consciousness that grasps that which is presented." Painting and writing brings me into a kind of communion with my subject matter—it returns me to the encounter. And when the work is good, I can share it with others.

*Santiago de Compostela
pilgrim badge*

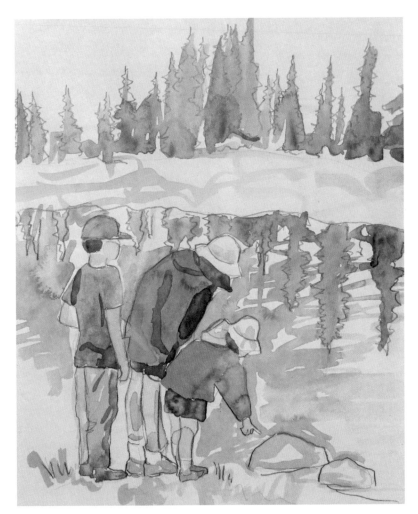

A sketch from an outing to Shadow Lake, a family favorite. We used to bribe our son and daughter by telling them that Mount Rainier was like the giant ice-cream cone they were going to eat after we got home.

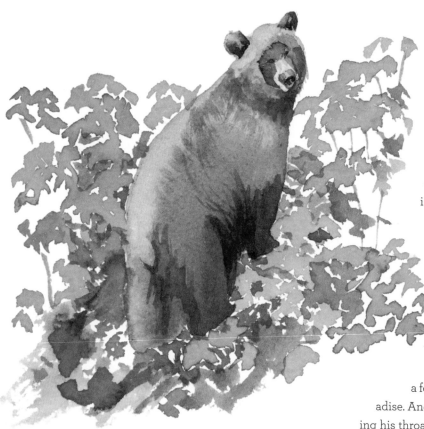

American black bear (cinnamon phase)
on the Westside Road

short distance from the Nisqually Entrance, on a rainy day. Only the first three miles of the road are open to cars: a few years ago, enormous boulders fell near Dry Creek, leaving huge craters in the road; now the rest of the road is closed to all but hikers and cyclists. Alone on that day, I encountered an American black bear (*Ursus americanus*). I really couldn't pass the bear: on one side of the road were Mount Wow's cliffs and on the other a brambly descent to Tahoma Creek. In the heavy rain, I took some photos from a safe distance. When the bear finally moved upslope, it cast a wary look toward me.

Later that day I was excited to see a fox waiting to cross the road below Paradise. And a sooty male grouse appeared, puffing his throat to display beautiful courting colors of orange and gold. These wildlife encounters were unusual. I'd never seen so many wild animals at the mountain in such a short period of time. Perhaps the animals were less wary of humans because

In June 2020 I walked the closed Westside Road, in the southwest corner of the park, just a

they'd had the park to themselves most of the winter and spring due to mudslides, road closures, and the beginning of the COVID-19 pandemic.

On the last day of my visit, there was morning rain in the town of Ashford, where I was staying just outside of the Nisqually Entrance, but with hope I drove back up to Paradise, thinking there was a small chance that the mountain would reveal itself. Weeks can go by without anyone getting a glimpse of it! Driving the last stretch of road I could see some blue sky, and Mazama Ridge appeared along the east skyline. As I drove into the parking lot there were only six cars. It was a weekday, the weather was bad, and a lot of people were staying home because of the pandemic. With great anticipation I put on my boots, got out my ski poles, and began to walk in the snow that was still piled high above the parking lot—soft spring snow, perfect for walking, yielding just enough but not too much. Bits of the mountain came in and out of view in the mist, first Anvil Rock, then Gibraltar Rock, then Kautz Cleaver; it was like seeing these landmarks through a gauze curtain, yet the sun was shining on Paradise the entire time. I wanted to walk and walk, climbing higher and higher in hopes of seeing more of the mountain. It

was thrilling to know that I was completely alone. The sun was out now, but mists swirled and at any moment could create whiteout conditions.

How would I define that moment? Sublime. As I looked through the veil at the vastness of the mountain before me, I had no companion to share this experience with, nothing to distract me from the sheer vision of it. A singular moment of beauty. And then, my next thought, still excited but back down to earth: how am I going to paint this?

Following that, my imagination lurched away in a contrary direction: I thought of plunging into one of those treacherous hollows that encircle trees and are hidden beneath the snow. If I fell in, would anyone find me?

I chickened out. I did not want to be counted among the four hundred people who have died on Mount Rainier, ending up in the pages of *Accidents in North American Climbing*. Hikers can make it into those pages, too, if it happens on a mountain like Rainier. Sadly, the week after my visit, two lone hikers in the Paradise area were lost in separate incidents, and still have not been found. I took another photo and returned to the car. But it wasn't a defeat: I was already making plans to draw and paint what I had seen. And to read and learn.

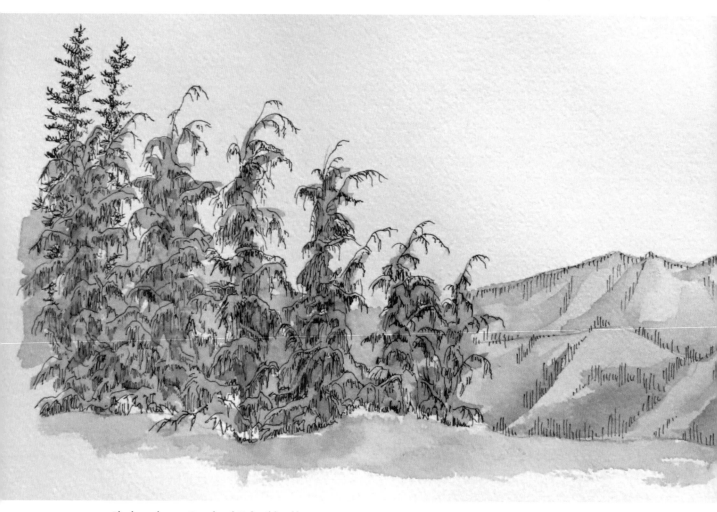

Alaska cedars on Sourdough Ridge (sketch)

Maybe my photos, sketches, and paintings are like the pilgrim badges that travelers got from shrines in the late Middle Ages in Europe on the pilgrimage routes. Painting and writing about my moment alone at Paradise attested to my trip, as the badges did for pilgrims, and allowed me to experience it again. The badges were an early form of souvenir that authenticated the pilgrimages, which in many cases were undertaken for healing.

Rainier has long been a place for cures. In the 1880s, a spa and resort were founded at Longmire. Floyd Schmoe, a Quaker who lived at the Paradise Inn in the early 1920s after seeing the horrors of World War I, wrote of his experiences in *A Year in Paradise*. His memoir is a moving tribute to Rainier and its curative powers. He wrote that "high above the world of people and things . . . [he was] acutely aware of the healing calm of the wilderness, the forest below and the skies above, and of the great silent mountain which stood [over him]." At that time he was "only a few months and a few miles removed, in time and space, from the suffering of battle areas in Europe, and he still "felt the physical and spiritual effects of it."

Once when I was feeling utterly defeated by life, when all my self-confidence and hope for the future was derailed, I stood on Sourdough Ridge above Sunrise on the way to Dege Peak, looking at a graceful colonnade of Alaska cedars (*Chamaecyparis nootkatensis*), dwarfed, buffeted by snow and wind as they clung to the ridgetop, with ancient trunks still spindly as saplings, so clearly under duress that I felt a kinship with them. Then I looked back across to the incredible girth of the mountain. So out of the ordinary is its scale and how rare the flowers and trees. I thought, *This world exists whether I do or not, yet it includes me because I am here to appreciate it. If this beauty can exist and I am here to see it, then it follows that everything about this place matters. And I matter in relation to it.* This is not a statement of verifiable fact, but rather a truth of the heart and spirit that feels as real as the Alaska cedars. This feeling of identification with the park has always inspired me to learn about its rich history and ecology. Each new thing that I have learned has deepened my love and appreciation for it.

Areas of the Park

The total area of Mount Rainier National Park is 369.34 square miles, bigger than New York City, including Manhattan and its five boroughs. With

over 250 miles of maintained trails, including a 93-mile footpath around the mountain, and 120 miles of roads, you can travel to many different parts of the park and discover a unique character in each place.

The mountain's major drainage basins can be divided roughly into five parts: The Carbon River in the northwest, Puyallup River in the west, Nisqually River in the southwest, the Cowlitz River in the south, and the White River in the northeast. The greatest amount of precipitation occurs at Paradise (often as snow) and the lowest amount at the White River. One inch of rain holds as much moisture as ten inches of snow, making Carbon River the wettest sector since most of the precipitation falls as rain there. It is one of the few places in the world designated as an inland temperate rain forest, receiving 70 to 90 inches of precipitation each year.

Mount Rainier does not straddle the Cascade Crest, but because of the mountain's huge size, its east side falls in the Cascade rain shadow. Thus the ecosystem on the east side is much drier and warmer than that on the west side. Also contributing to the diversity of the park are the hugely varied elevations, not to mention the different silhouettes of the mountain that you see from many vantage points. From Paradise (5,400 feet) you see the classic view with Gibraltar Rock prominent on Rainier's east side. From Sunrise (6,400 feet), you take in a panorama that begins to the east with Little Tahoma. In some sections of the park, like Ohanapecosh and the Carbon River (both around 1,900 feet) there is no view of the mountain. Instead you are surrounded by enormous trunks of Douglas firs, western red cedars, and western hemlocks, the piers and pillars that support the green vaults of conifer boughs.

Geology: Deep Time

In every area of the park the past is alive in the present. You can't help but be aware of geology's deep time, a phrase coined by John McPhee in his classic book *Basin and Range*. The mountain's vastness and origins in volcanism, still quite visible, make you intensely feel the earth and the beginnings of time. Approximately 500,000 years ago Mount Rainier began to build upon the eroded remains of an earlier pre-Rainier that was active 1 to 2 million years ago. The more recent Rainier was created over four periods of volcanic activity. In very active stages, lava often flowed out fifteen miles from the summit. Eruptions slowed about 160,000 years ago; then a period of erosion removed much

of the north and south flanks and considerably reduced the summit elevation. Dikes and vents on the upper east side of the mountain fed the lava flows, resulting in the building of Little Tahoma, one of Rainier's most recognizable subpeaks.

About 40,000 to 15,000 years ago more eruptions occurred, resulting in the formation of Liberty Ridge, Willis Wall, upper Curtis Ridge, Gibraltar Rock, Wapowety Cleaver, Success Cleaver, and the Tahoma Cleaver. At a similar time, about 40,000

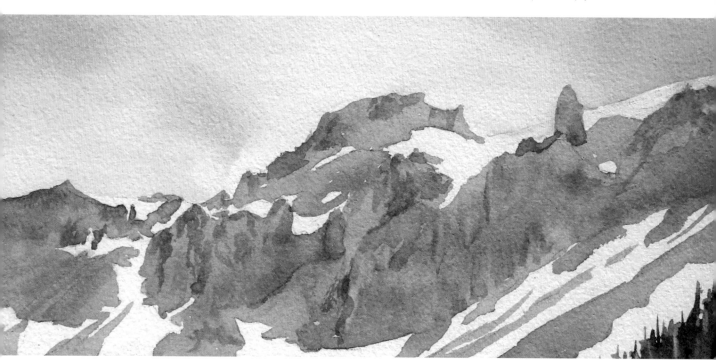

The result of pyroclastic flows hangs above Glacier Basin near Saint Elmo Pass in dramatic rock formations. (detail of watercolor on page 81).

years ago, a flank lava flow created Ricksecker Point and the rock beneath Narada Falls.

Due to the possibility of lahars (an Indonesian word meaning mudflow), Mount Rainier is considered the most potentially hazardous of the volcanoes in the Cascade Range. Lahars are fast-moving rivers of debris so powerful they can reach beyond the boundaries of the park. Other events, where eruptions or glacial meltwater release rivers of mud and rocks that do not exceed the park perimeter, are called debris flows. During the Holocene era, modern human history, three of the largest lahars flowed as far as Puget Sound. The Osceola Mudflow, 5,600 years ago, was triggered by a summit eruption that brought debris down to the White River. The National Mudflow happened 2,200 years ago and poured down the Nisqually River. The Electron Mudflow, which may not have originated in eruptive activity, ran down the Puyallup River approximately 500 years ago. This sort of lahar that can occur without warning raises concern among geologists. Other smaller debris flows have occurred at least sixty times on Rainier, the most famous being the Kautz Creek flood of 1947. It lasted for twenty hours, dislodging ice from the center of the Kautz Glacier and tearing out a section below the terminus two and a half miles long and about sixty feet deep. This powerful flow ripped trees from their roots and brought down a slurry of rocks, silt, and giant boulders. The riverbed behind the Nisqually Entrance station was raised six feet.

All notions of the mountain being a permanent geological formation have to be put aside when you take into account these recent events. In 1963, enormous rockfalls from Little Tahoma Peak fell onto the Emmons Glacier. These triggered at least seven different avalanches of rock debris that traveled four miles down the glacier and into the White River valley. This may have been caused by a small steam explosion near the base of Little Tahoma. These avalanches may have had velocities of up to ninety miles an hour. When so much mass moves so quickly down a slope, air becomes trapped beneath it, cushioning it and allowing it to travel farther than it otherwise would. Hike anywhere near the mountain in high summer and you will hear rumbling avalanches of rocks and ice. The mountain never rests.

Nisqually Entrance Gate

Architecture: Layers of Memory

There are other scales of time at Rainier besides geological time. For me, the park's historic archi- tectural landmarks are an integral part of the park experience. As Ethan Carr wrote in *The Natural Style and Park Design*, "The beauty and

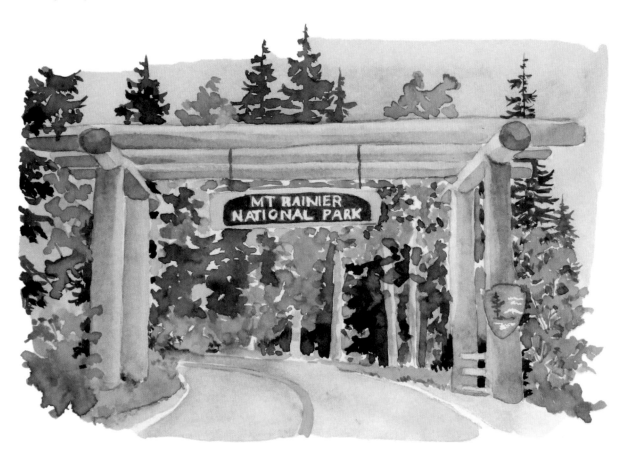

significance of a landscape should never be narrowly construed; there are multiple . . . narratives and layers of commemoration in any . . . landscape."

The National Park Service's first director, Stephen Mather, and his assistant, Horace Albright (who was to become the next director), guided the architectural development of national park buildings. The "rustic style" used in the national park structures depended on an organic approach to architecture: siting the buildings carefully so that they would be subordinate to the natural beauty around them and using local materials so that they would be harmoniously integrated into the surroundings.

When Secretary of the Interior Richard Ballinger visited Rainier in 1910, he proposed a rustic gateway at the Nisqually park entrance. Four cedar log columns almost four feet in diameter created the base, and across it were laid three log beams. A park sign was added, using the rustic style lettering found in many national parks. When the entrance gateway finally deteriorated in 1973, the logs were replaced but the original intentions were faithfully replicated. The style can be seen throughout the park: concrete bridges beautifully faced with local stone, visitor centers displaying local motifs, as well as the entrance arch that employs timbers from the surrounding forest. In fact, there are forty-four structures in the park that have been listed on the National Register of Historic Places.

I savor the feeling of "temporal poignancy," in the words of poet and scholar Susan Stewart, when seeing the old structures of Rainier, whether they have been restored, or have fallen into disuse and near-ruin like the Longmire mineral baths. That awareness of the layers of memory, both my own and the collective memory of all past visitors, has been a significant part of my pleasure in visiting Rainier over many decades.

Shooting star

Natural History: Refugium

The most recent ice age is long past, but it lives on in the glaciers of the high mountains of the West. As early as 1893, in the Congressional campaign to establish Mount Rainier as a national park, geologist Bailey Willis (for whom the Willis Wall is named) wrote a document in which he described Rainier as "an arctic island in a temperate sea." Biologists call these ice worlds, and pockets of other ecosystems that were more widespread in the past, *refugia*. Human beings have always been destructive of megafauna. During the Paleolithic period, humans played a large role in eradicating mammoths and other large mammalian species. Through the use of fire, Native Americans also had a significant impact on the biological landscape of the area that is now the park. Since European settlement, the changes have been much more radical in all of Washington State, with the exception of areas like Mount Rainier National Park. For now, Rainier's glaciers and ancient forests remain as reminders of what once used to be.

A mountain requires certain conditions to be as glaciated as Rainier is. The heavy rainfall of the Pacific Northwest creates ideal conditions, since what falls as rain in lower elevations becomes snow between 5,000 and 8,000 feet. Snow begins accumulating in early November at Paradise and builds to depths of eighteen to twenty-three feet by March or April. Above 8,000 feet less snow falls because the cloud cover does not usually exceed that height. Snow covers roughly thirty-four square miles of Rainier at the end of summer, either as glacier or permanent snowfield. That is more than the area of all the other glaciers and snowfields of the Cascade volcanoes combined. The Carbon Glacier is almost six miles long and is 200 feet thick at its center. It reaches into the valley farther than any of the other glaciers. Because of its thickness, it has not shrunk as much as others have in recent decades. But the Paradise Glacier has receded dramatically: it used to contain the Paradise Ice Caves, one of the principal "sights" of the park long ago. I saw them before they disappeared by the early 1990s.

For many plants and animals the high mountains are literal refuges. Some of the animals that lived during the ice ages still survive in *refugia* like Mount Rainier National Park. An example is the rare Cascade red fox (see sidebar, page 67). Many of the trees one sees at Mount Rainier are vestiges of what once covered the Pacific Northwest in colder periods. Old forests surviving for over

1,000 years still grow in protected valley bottoms in the park and on slopes along Ipsut and Cataract Creek drainages, both tributaries of the Carbon River. The oldest tree in the park, an Alaska cedar (*Chamaecyparis nootkatensis*), grows near the Wonderland Trail along the Ipsut Creek drainage and is 1,200 years old and seven feet in diameter. The Grove of the Patriarchs at Ohanapecosh and the Nisqually River drainage near the Cougar Rock Campground both have stands of trees that are over 1,000 years old.

Of plants, David Biek writes in *Flora of Mount Rainier National Park*, "The park, to an unhappy extent, is an island in the midst of a landscape that has been greatly modified by human activities over the past one hundred years, a biogeographical island where plant communities are preserved that outside the Park are becoming more rare." He continues, "Plants cannot migrate, as some animal species can." Some plants may be able to extend their ranges. But in many other cases, with climate change they will not survive because

it would take them decades or even centuries to adapt to new, warmer conditions.

Mount Rainier provides a refuge for humans too. Recently many have suggested that even though we are living in a new phase of history, the Anthropocene, we are still walking around with the brains of Paleolithic humans. Perhaps for some of us, the ice-bound world of high mountains with their unusual plants and megafauna speaks to some deep part of our brains, vestigial but still very much present. Once we meet our basic needs for food and shelter, we are still missing the connection to the natural world we adapted to early in our species' existence on this planet. Some of us have the luxury of having our needs met for food and shelter, and owe it to those who don't to make the world a more just place, so everyone can reconnect with the health-giving world of nature. We also have an obligation to other species to preserve and protect them and the planet.

Cascade aster and arctic fritillary

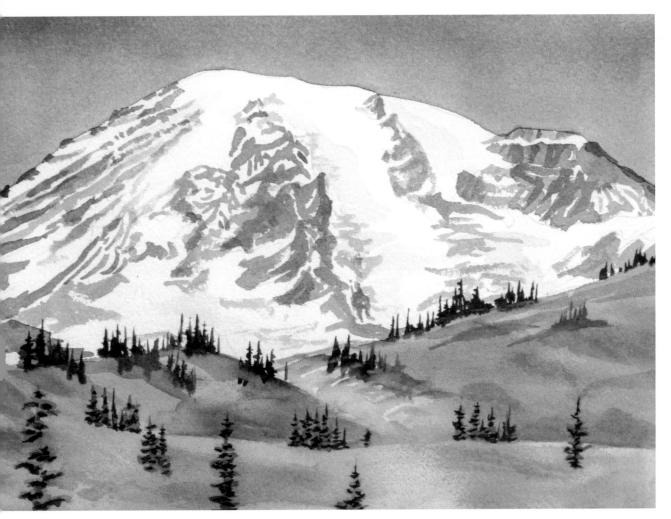

Mount Rainier from Paradise in autumn

RAINIER'S FOREST ZONES: PLANT NEIGHBORHOODS

In *Flora of Mount Rainier National Park*, David Biek describes the various forest zones of Rainier, where a single tree species dominates as a climax species: "Lower elevation Western Hemlock Zone, mid-elevation Silver Fir Zone, and high-elevation Mountain Hemlock Zone. Then these zones can be further divided into 'associations,' with shrubs and herbs that you count on seeing within any given zone. You could also call these 'plant community types.'" A specific example would be the subalpine meadows, which could be subdivided into five groups, although not all groups are present in a single area of the park:

1. *Phyllodoce-Cassiope vaccinium*, a group of low-growing heather and huckleberry shrubs
2. *Valeriana sitchensis-Carex spectabilis*, featuring lush herbaceous perennials, like the Sitka valerian (see Wildflower chapter)
3. *Carex nigricans* group, dominated by dwarf sedges
4. Rawmark and low herbaceous group, communities that colonize newly opened ground
5. *Festuca viridula* group, dominated by bunchgrasses

The illustration on the facing page shows plant community type 1: a heather and huckleberry meadow just above Paradise on the Skyline Trail, with the heather and huckleberry in the foreground and subalpine firs and mountain hemlocks screening a view to the southwest of the Tatoosh Range.

I've devoted an entire chapter, Wildflowers, to the *Valeriana sitchensis-Carex spectabilis* group, because it describes the lush meadows of Paradise and other subalpine meadows in the park.

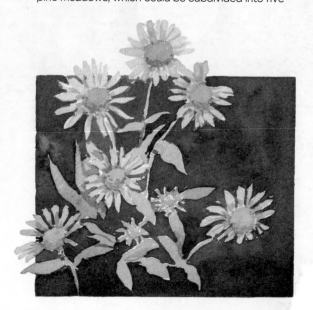

Mountain daisy

Phyllodoce-Cassiope vaccinium *meadow type featuring heather and huckleberry (sketch)*

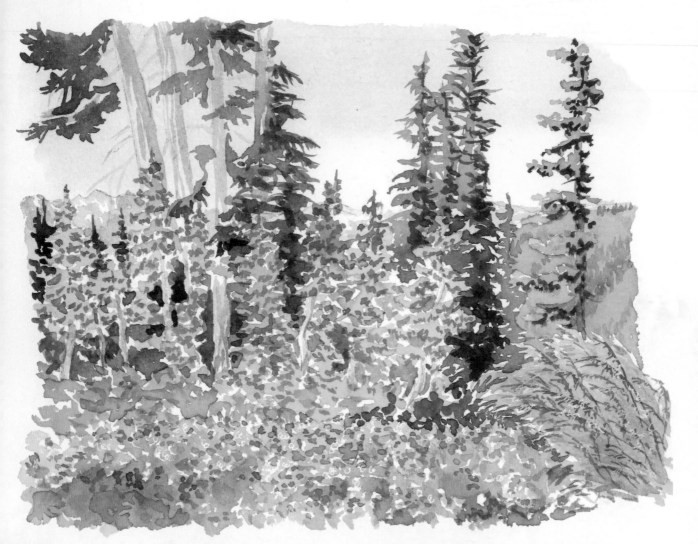

Artists at Rainier

Many artists have visited Rainier. Famous Hudson River School artist Sanford Robinson Gifford traveled the Washington Territory in 1874 and created an oil sketch, *Mount Tacoma from Puget Sound*, which he used as a basis for two later and much larger paintings. Light-suffused and atmospheric, his work perfectly captures the way Rainier seems to hover above the Sound. Printmakers Waldo and Corwin Chase lived a Bohemian lifestyle in the 1920s and 1930s in the attic of a store in the coal mining town of Fairfax, Washington, very close to the park's Carbon River Entrance. They created some beautiful Japanese-style woodblock prints of Rainier. Paul Morgan Gustin did an admirable etching of Rainier from Paradise in the early twentieth century as well as several marvelous Impressionist-style oil paintings. Abby Williams Hill, Tacoma artist of the early twentieth century, painted and sketched at Rainier on two separate occasions (see sidebar, page 112).

A more recent artist, as well as a park ranger and a climber, was the late, great Dee Molenaar. No one else ever sketched or painted Mount Rainier with such deep familiarity and knowledge. I have a copy of his wonderful oblique view pictorial landform map, "Mount Rainier National Park, Washington: 'Where Flowers and Glaciers Meet.'" In addition to naming all the major attractions, it illustrates eleven different views of the mountain. To see the artist's work, visit the Ashford Creek Gallery, owned by Jana Gardiner and Rick Johnson. Other well-known artists' works hang in their museum gallery, and they carry a wonderful selection of books on Rainier plus a historic postcard collection, as well as their handsome Rainier-inspired pottery.

English poet Percy Bysshe Shelley ends his poem "Mont Blanc" by asking what the mountain would be, "If to the human mind's imaginings / Silence and solitude were vacancy." In other words, without our interpretation, perhaps the mountain does not have a voice and remains nothing to us. When I go to Rainier and take the time to photograph, sketch, and write, I am opening up those visits to my "mind's imaginings"; through my art and research I give meaning to my experiences. Shelley concluded by saying that the mountain has a voice, "not understood by all, but which the wise, and great and good / Interpret, or make felt or deeply feel." Artists, photographers, and writers create art from their deeply felt experiences and become interpreters who help park visitors and

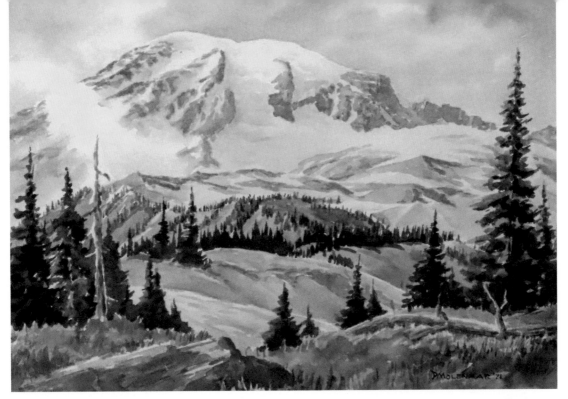

Untitled watercolor of Rainier from Paradise by Dee Molenaar (courtesy of his family and the Ashford Creek Gallery)

others better appreciate the park. Park rangers and park volunteers do the good work of educating and enlightening visitors, as well as protecting fragile ecosystems. Scientists study and disseminate their findings to the public and the government, and in some cases succeed in making political change that protects our wild places.

My aim in this book, as both artist and writer, is to take you on a heartfelt pilgrimage around the mountain in words and sketches and paintings. I hope the excursion will help you to hear Rainier's voice. By paying close attention, we will be motivated to protect this rare refuge and all the beings who inhabit it.

TOOLKIT & METHODS:
ROCKS, TREES & MOUNTAIN TORRENTS

Because I usually go to the park for day hikes to new or favorite destinations, I don't have much time for extended painting outdoors, or on-site plein air painting. I travel with an artist's toolkit and often only the barest essentials in a plastic bag: sketchbook, pencil, eraser, and drawing pen. When I do have time to paint, I bring the following kit for watercolor painting:

- **SKETCHBOOK:** I use 100 percent rag watercolor paper, cut to size and spiral bound
- **HB DRAWING PENCIL**

- **PLASTIC ERASER**
- **FELT-TIP OR BALLPOINT DRAWING PENS**
- **WATER CONTAINERS** (plastic yogurt containers work well) or water brushes
- **OLD PLASTIC WATER BOTTLE WITH LID** to hold discarded dirty paint water
- **PAPER TOWELS OR RAGS**
- **BRUSHES**: #4 and #6 round sable, ¾-inch flat brush (synthetic is fine for the flat brush)
- **PAINT AND PALETTE**: lightweight plastic with at least twelve wells. (It's best to load your tube paints onto the palette a couple of days before heading out, so they have a chance to dry.) This is my complete palette, but your own choices may be different, and you can also use a lightweight outdoor kit, pre-made with pans of color, if you prefer:
 - Red: permanent alizarin crimson, pyrrol scarlet
 - Yellow: hansa yellow medium and hansa yellow deep
 - Blue: phthalo blue red shade or ultramarine blue and phthalo blue-green shade
 - Plus a few other colors: yellow ochre, quinacridone burnt orange

While there, I keep my eyes open to everything— the plants, the trees, the wildlife. I always have my camera ready and I take a lot of photos. Sometimes photos don't capture qualities of light and color, because they tend to portray average light and shade, so I make notes about these important features of the visible world, too. Sometimes there is simply no substitute for drawing and painting on location. When I get home, I look at all of my sketches and photos, and write in my notebook about each one, to remember exactly what I saw and what I felt as I experienced things. I load the photos onto my computer and give them titles.

Although immediate reactions are important in the making of art, reflection is also key, and that takes time. Thomas Moran, eminent late nineteenth century painter of Yellowstone and the Grand Canyon, once said, "I must know the geology. I must know the rocks and the trees and the atmosphere and the mountain torrents and the birds that fly in the blue ether above me." So next I look things up in field guides, identifying plants, place names, and histories. I study maps to find exact locations and what I might have been seeing across a river or valley. Memory is never exactly like the immediate experience of being some-place—a memory becomes layered with every new fact discovered about a place or a plant or a wild animal. The experience becomes more com-plex and rich, and the physical act of painting is charged with recollection and new knowledge. I am aware as I paint of an intense desire to communi-cate all that I feel and know. And I am aware that I often come up short, but the mere attempt seems entirely worthy.

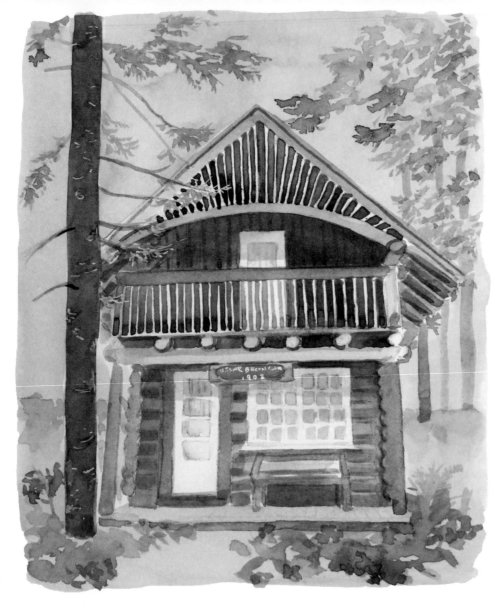

*Oscar Brown cabin,
Nisqually Entrance*

Nisqually Entrance & Longmire

Nisqually Entrance

The Nisqually Entrance to Mount Rainier National Park is the southwest entrance tucked into a tall forest of Douglas firs, hemlocks, and western red cedars. On a warm day it is still cool, and even when skies are overcast the bright hues of the evergreens cheerfully welcome visitors to an incomparably beautiful and diverse national park.

Nisqually is the most visited entrance station because it is closest to Paradise, Rainier's major attraction. On a sunny summer weekend, cars can sit, backed up for a mile waiting to get in (the Park Service is investigating ways to reduce car traffic in the park). Unlike other entrances, it is open year-round, and unless there is an extreme weather event you can always drive as far as Longmire. In addition to the rustic entrance gate, the Nisqually Entrance Historic District includes several remarkable buildings. Among them are the Entrance Station (1926), where visitors pay fees, the Superintendent's Residence (1915), the Ranger's Residence (1915) and the Oscar Brown Cabin (1908). The district was added to the National Register of Historic Places in 1991.

To find the Oscar Brown cabin, look to the south after you pass through the Nisqually Entrance Gate. The

Vanilla leaf (sketch)

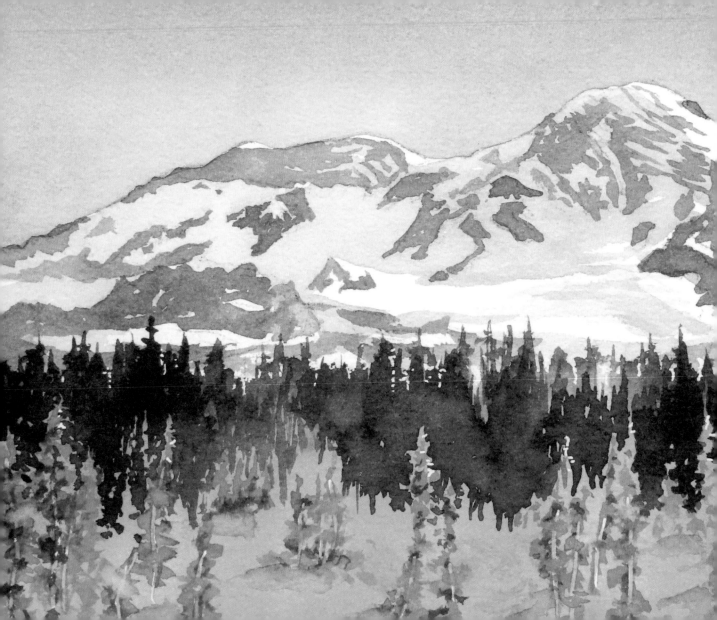

cabin was named after the first permanent ranger in the park. It served as a checking station for visitors entering the park and as the park's headquarters until 1916. Enjoy the playful design of the cabin, and its upper story, with the arched log and smaller logs that radiate upward, creating a sunburst pattern.

Because it spreads underground through rhizomes, vanilla leaf can cover huge swaths of deep forest. One early summer morning, with overcast skies and partial sun at times, when I was strolling around the Nisqually Entrance and then driving up to Longmire, the floor of the forest glowed neon green because of the emerging carpet of vanilla leaf (*Achlys triphylla*) foliage. It didn't seem to matter whether the sun was shining, because the leaves provided their own illumination. In late spring when the plant blooms, small upright white spikes rise from the juncture of the three-part leaves. According to Mary Fries, in *Wildflowers of Mount Rainier and the Cascades*, pioneer women used the dried vanilla-scented leaves in their linen drawers, and fishermen wrapped trout in the fresh leaves.

An unfamiliar view of the mountain is seen from Indian Henry's Hunting Ground, approached via a trail along Kautz Creek, a few miles beyond the Nisqually Entrance Gate. It is one of the finest alpine meadows in the park. The round trip on the trail is fourteen miles, so it is not for the faint of heart. To the left is Liberty Cap, the large bowl in the center is the Sunset Amphitheater, and to the right is Point Success. Indian Henry, whose native name was So-To-Lick, may have been a Yakama or Klickitat by birth, as were a number of the westside Nisqually tribe he eventually became part of. He knew Mount Rainier well, guiding several climbing parties with their horses to the glaciers. He frequented several hunting sites around the mountain, and the meadows that are his namesake were among his favorites. In 1908, Wigwam Tent Camp was established there, and although the camp was abandoned in 1918, a backcountry patrol cabin remains.

Mount Rainier from Indian Henry's Hunting Ground

Longmire

Longmire, 6.4 miles from the Nisqually entrance station, encompasses the operations center for the park, with a ranger station, museum, and the National Park Inn. The architecture of most of the historic buildings is enhanced by river rocks from many different mudflows that issued from the nearby Nisqually River. The site is named after James Longmire, a pioneer who in 1883 came upon the warm mineral springs here. He returned the next year to build a spa and resort, the Longmire Medical Springs, and eventually the Longmire Springs Hotel.

The legacy of the past is quite widespread in the Longmire Historic District, in the form of the rustic wood and stone architecture of most of the buildings. The administration building, community building, a service station, and two comfort stations in the campgrounds are listed on the National Register of Historic Places, and in fact they are one of the most notable groups of buildings in any US national park.

On a rainy summer day I was walking along the Trail of the Shadows at Longmire

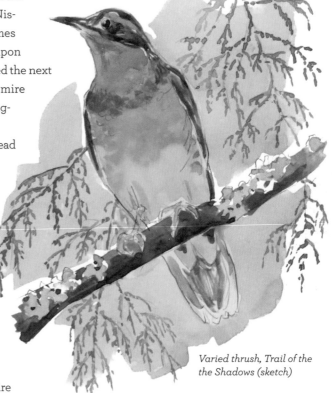

Varied thrush, Trail of the the Shadows (sketch)

Elcaine Longmire's cabin

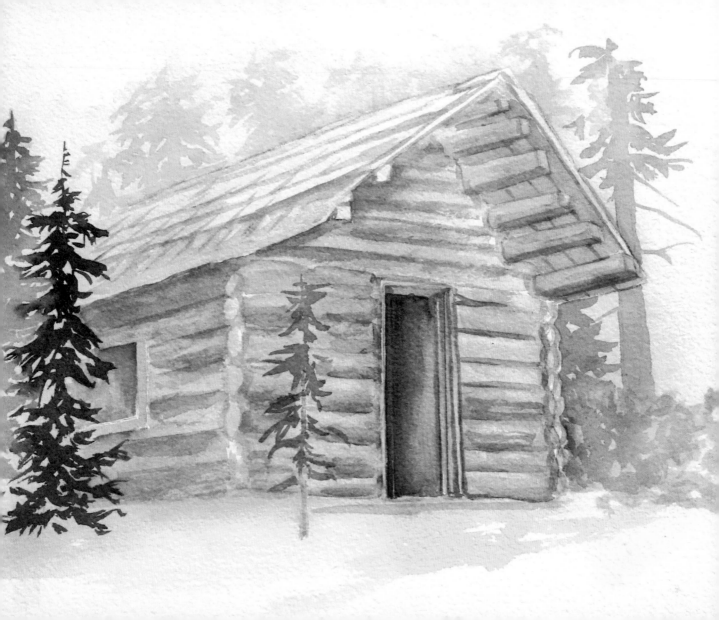

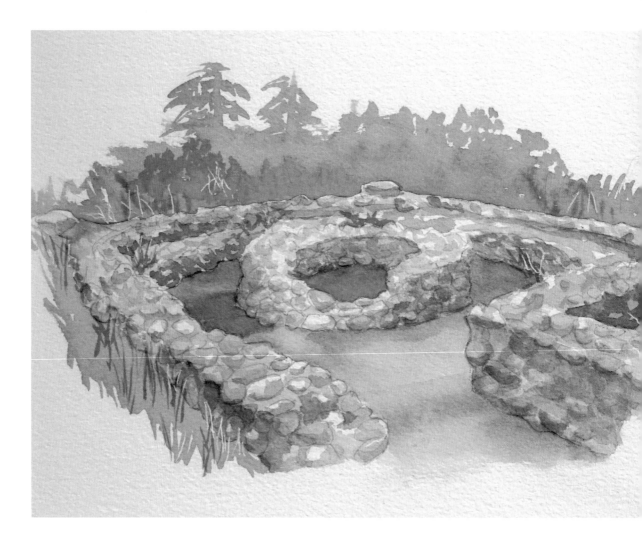

and I did not encounter any other human beings. But a pair of varied thrushes (*Ixoreus naevius*) was courting in a cedar tree, and I sketched the male who was looking up at the female. Even though this bird is common to forests in the Pacific Northwest, it is rarely seen since it is quite shy and flies off the minute people appear. You have probably heard varied thrushes many times, though. They have a high-pitched two-note song that you might mistake for a marmot whistle, except that you hear it in the forest and not in high-country meadows or talus and scree fields. If you listen for several minutes you will notice the first whistle is pitchless, and then several seconds later the next sets of whistles are in major thirds and harmonize. I always thought they sang in a minor key, but perhaps my perception was influenced by the dark forests where I always hear them.

The Trail of the Shadows, a loop trail of less than a mile, wanders through forest that encircles an open meadow (Longmire Meadows) with bright mineral-tinted ponds across the road from the inn. The oldest surviving building in the park is a cabin on this trail, built by Longmire's son, Elcaine, in 1888. The trail name likely describes the tall forest of western red cedars, western hemlocks, and Douglas firs; when I walk here I experience the moody shadows of the past in the shapes of derelict stone mineral baths. Rusty orange in places, the mineral springs are still bubbling but are not used. At one time there were up to forty-nine springs, and my illustration depicts a circular bath that once housed a cedar tub for guests. The rainy day I was there I saw no other visitors, so it was easy to imagine myself surrounded by ghosts of the past. As Susan Stewart writes in *The Ruins Lesson*, "Encountering a ruin, we are meeting presence on its way to absence. We become aware of the transience in time that is ours as well."

Mineral baths at Longmire

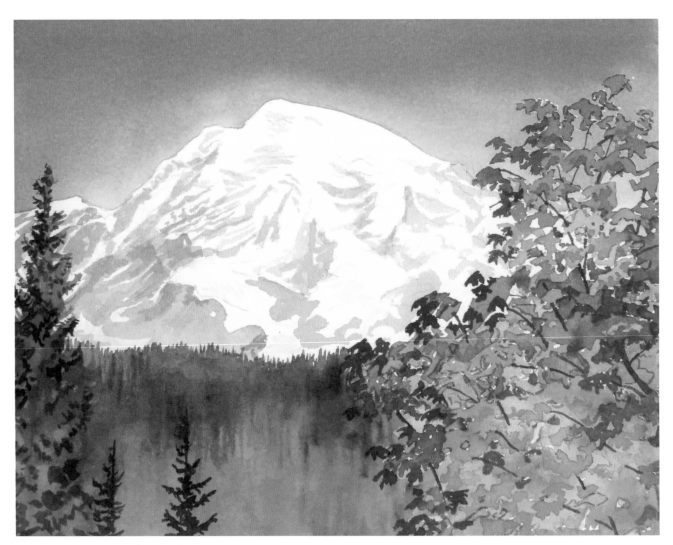

Autumn view of Rainier from Longmire

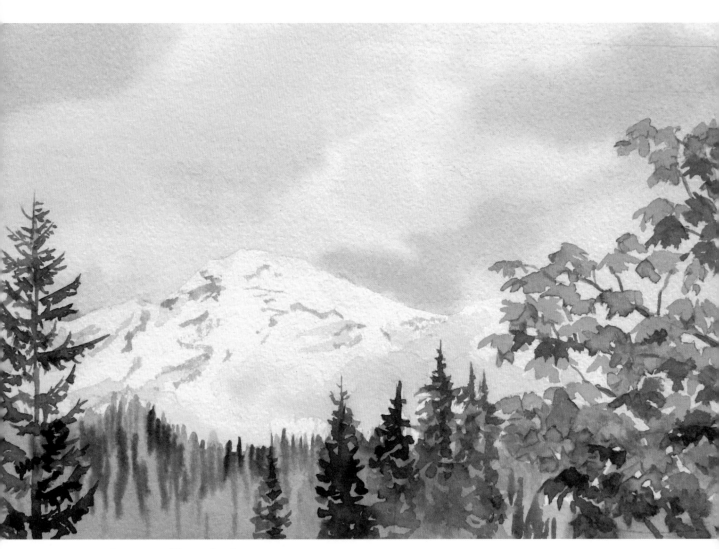

Spring view of Rainier from Longmire

The previous pages show two views from the same spot on the steps of the Rainier National Park Inn, painted two years apart. I must have used zoom for the photo of autumn color—the mountain appears so much larger in that image. But I like the soft quality of late spring Rainier. The mists parted for all of twenty minutes for that photo.

When the Nisqually Suspension Bridge was reconstructed in 1951, attempts were made to recapture some of the rustic quality of the original log structure of 1924. Instead of logs, the new bridge used milled timbers connected by exposed bolts. But the form is almost identical with crosspieces and supporting beams the same. With nearly invisible suspended wire cables that disappear into the surrounding forest, and roadway planks made of wood, the bridge blends subtly into its sylvan environment. I enjoyed painting the fretwork of the crosspieces, putting them together like a puzzle, imagining myself an

Nisqually Suspension Bridge, Longmire

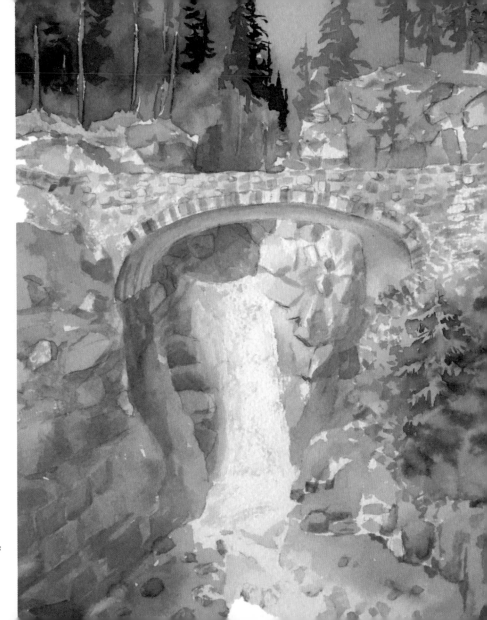

Christine Falls

engineer as I drew and painted. To find the bridge, drive up the hill beyond the Park Service buildings and housing.

Christine Falls was named after Christine Louise Van Trump, whose father, together with Hazard Stevens, made the first ascent of Mount Rainier in 1870. The falls are a series of small cataracts of Van Trump Creek, at the base of Cushman Crest eight miles east of the Nisqually Entrance.

Walking to the south below the bridge brings you to one of the most popular overlooks in the park. This grand romantic view shows the rustic-style bridge framing the falls and carrying the Nisqually road over a dramatic narrow box canyon of jointed granodiorite. The bridge is a reinforced concrete spandrel arch, handsomely faced with local stone, and engineers find it one of the most successful examples of a road-related structure integrated into a natural environment.

The Paradise River thundered along below Eagle Peak, giving glimpses of very beautiful falls. . . . Narada Falls are fine beyond description. They spring from a rock hundreds of feet high and break into spray through which, when the sun shines, can be seen a beautiful rainbow.
—ABBY WILLIAMS HILL JOURNAL

Narada Falls are perhaps the best known and appreciated waterfalls in the park, easily accessed off the Nisqually road. The 168-foot falls were named in 1893 by Arthur Knight of Tacoma, for the Narada branch of the Theosophical Society of Tacoma. *Narada* is a Hindu word that means "pure." In early June when I visited, the falls were roaring. Icy snow covered parts of the trail; some visitors slipped and skated in carefree fashion, while others tentatively looked for footholds in the steep snow alongside the path.

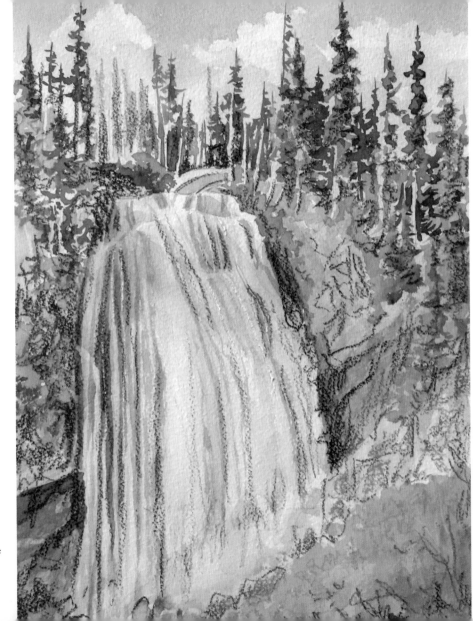

Narada Falls

STEPHEN MATHER: THE GOOD THAT HE HAS DONE

Gazing upon this great white mountain, rosy at early dawn, white at noon, changing back to warm glow at the close of day, inspires the highest and noblest thoughts of grandeur, grace and beauty.

—STEPHEN MATHER, *THE MID-PACIFIC MAGAZINE*, 1920

In 1905 Stephen Mather joined the Sierra Club on its annual outing to climb Mount Rainier. According to Horace Albright, his lifelong friend and his assistant during his tenure as the first director of the National Park Service, on that climb, "he became good friends with Will Colby and Joseph Le Conte from the Sierra Club as well as members of the Mazamas." Many of these people were associates of John Muir, and their nightly campfire talks made a lasting impression on Mather, as they shared their faith and devotion to conservation and other elements of Muir's philosophy.

Mather had lifelong problems with bi-polar disorder, and it is said that this climb of Rainier cured one of his early bouts of depression. Being in nature had a very salutary effect on him for his entire life.

Mather Memorial Plaque, Longmire

He made his fortune in California, creating the advertising campaign for the Pacific Coast Borax Company, and then determined to spend his life advocating for parks.

Mather shaped Mount Rainier National Park quite significantly. According to Theodore Catton, in *National Park, City Playground*, Mather "gave Rainier more personal attention than any subsequent director." His vision

for the parks was to create partnerships with private concessionaires who would provide hotel accommodations and other visitor services under contract, while the government remained in charge of park infrastructure. He believed these partnerships would help to preserve the parks as well as encourage use by the public. Very soon after being appointed director of the National Park Service, he encouraged a group of Seattle and Tacoma business leaders to build a hotel at Paradise, which was a motley assortment of tents and cottages. Mather believed that the structures in parks needed to reflect the surroundings and to harmonize, not distract from, the beauty that surrounded them. This aesthetic came to be known as National Park Service "rustic." The Paradise Inn, with a design something like Old Faithful Inn in Yellowstone, with steeply pitched roofs, opened on July 1, 1917, the first year of the National Park Service's operation.

There were conflicting visions of what the parks should be. The businessmen saw their concession as a profit-making endeavor and were frustrated by the number of day-use visitors. They also hoped that Rainier would generate regional growth. On the other hand, Mather's lifelong goal was to make the parks accessible to as many people as possible, so that they could come and restore themselves as he had. This was not always in keeping with

an environmental ethic of conservation, because hordes of visitors often have a damaging effect. He wanted roads in all the parks; for Mount Rainier National Park, he envisioned a grand highway circling the mountain, which would have linked the Westside Road with Mowich Lake and the Carbon River. Though this was never built, the Park Service did secure funding for the highway that connects the White River Entrance with Chinook and Cayuse Passes, Ohanapecosh, and Paradise. It was constructed in the years after Mather's death and named the Mather Memorial Parkway.

In 1930 twenty-eight bronze plaques were cast to honor Mather in parks and national monuments. He probably would not have approved, since he opposed the idea of statues and monuments in parks, but this happened after his death. Mount Rainier received two of the plaques. One is rather tucked away and hidden in a grotto to the north of the Longmire Administration Building and the other is at Tipsoo Lake at Cayuse Pass. Both were dedicated on July 2, 1932. The inscription reads:

He laid the foundation of the National Park Service. Defining and establishing the policies under which its areas shall be developed and conserved unimpaired for future generations. There will never come an end to the good that he has done.

Paradise

From the Nisqually Entrance Gate to Paradise, you'll travel nineteen miles, and from 2,000 feet in elevation to over a mile high, at 5,400 feet. It is said that when James Longmire's daughter-in-law Martha first saw the meadows, she exclaimed, "Oh, what a paradise!" For centuries people have visited this place. Long before white settlers arrived, Native peoples, including the Nisqually, Yakama, Puyallup, Muckleshoot, and Upper Cowlitz, stayed in the meadowlands that surround Paradise in late summer for berry picking and hunting. In late August and early September, the huckleberries and blueberries were lush and ripe: animals sought out the ripening fruit too, many of them in their finest fur, after feeding plentifully in summer.

South of Paradise were heavily forested areas that burned in a fire in 1885. The limbs of the burnt Alaska cedars fell off, and then the bark, so that gradually all that remained were silvery trunks, and afterward the area was called the Silver Forest. Climbers and campers spread tents all over the meadows, and cottages sprang up, too, all without any cohesive plan. There was a demand for overnight accommodations and the tents and cottages were not sufficient.

When Stephen Mather asked for a hotel to be built at Paradise, the architect decided to use local materials in the design and harvested timber from the Silver Forest. Alaska cedar also was used to build the interior furniture, including massive tables and chairs. Hans Fraehnke, a German woodcrafter, made the piano case as well as the grandfather clock.

On a day I visited in mid-June, there were still many feet of snow at the Paradise parking lot. Skiers and sledders crowded the slopes. I walked toward the Paradise Inn, still locked up and in its winter sleep.

Paradise Inn, June snowfall

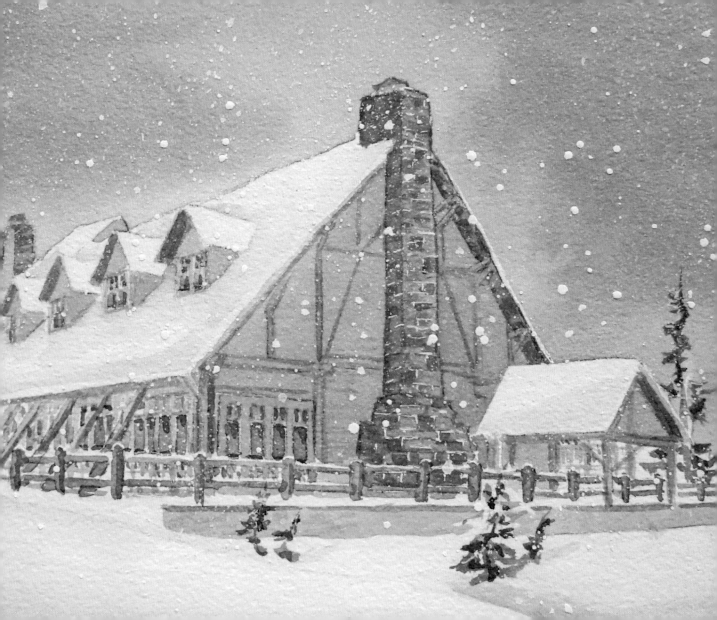

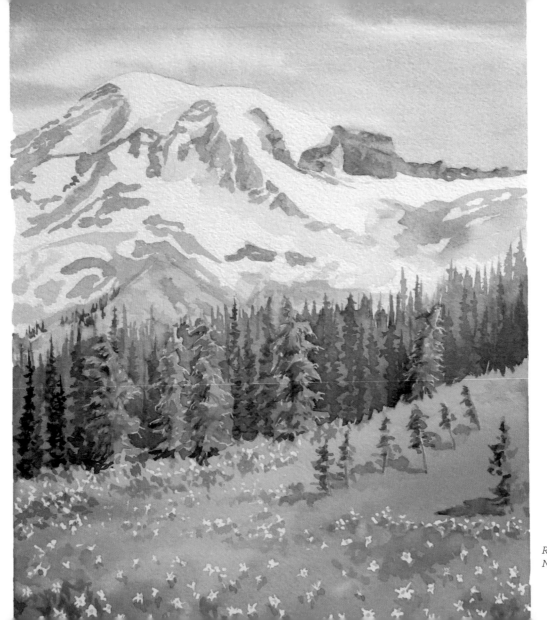

*Rainier from
Nisqually Vista*

In later summer, after the snow melts, the wildflower meadows are unparalleled. Because of the unique topographical situation of Rainier's southwest slopes, they absorb the winter moisture of the Pacific Northwest storms (see Wildflowers, page 114). Visitors come from all over the world to enjoy the spectacle of the flowers. Once you are a mile or so away from the parking lot the crowds thin and you can experience the mountain more calmly. There are miles of trails here, including the Nisqually Vista, Alta Vista, Skyline, Golden Gate, Paradise, and High Lakes Trails.

The trail to Nisqually Vista is paved, and it's wonderful that people with limited mobility can come out to enjoy the remarkable view. Surprisingly, at 8:30 in the morning one day in late July there was not another soul there. The trail begins gently in meadows starry with white avalanche lilies (*Erythronium montanum*), the first flowers to bloom after the snow melts. Nature here reveals its benign and pleasing aspect, but that gentle expression quickly gives way at the vista to dizzying drops and views of what poet Shelley called the "naked countenance of earth." For safety there is fencing; you look down over 2,000 feet to the foot of the glacier, and up almost two miles to the summit. These experiences of the sublime can be good for the spirit: we feel overwhelmed by the size and power, and our imaginations expand to try to encompass the enormous scale. As I stood there alone on that July day, I felt a sense of my own vulnerability, humbled, and yet strangely exalted by that. Scott Russell Sanders wrote,

The more we decipher, the more we realize that everything is connected to everything else, near and distant, living and nonliving, as mystics have long testified. This connectedness, this grand communion, is what I have come to think of as soul—not my soul, as if I were a being apart, but the soul of Being itself, the whole of things.

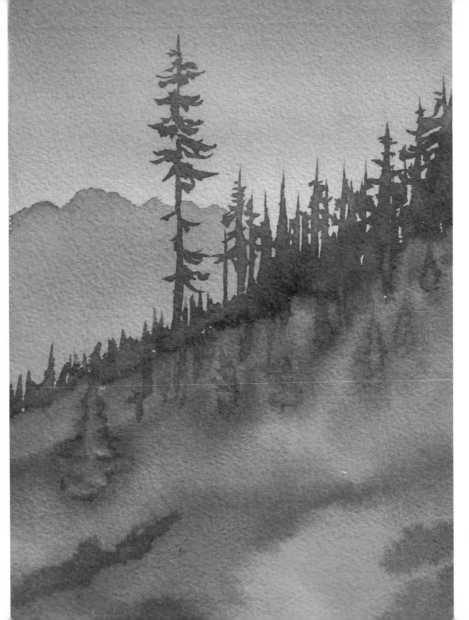

Hemlock in meadow at Paradise

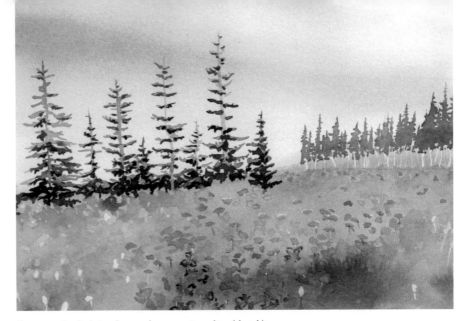

Spirea and subalpine fir meadow near Paradise (sketch)

In autumn, the foliage of huckleberry bushes, ashes, and heathers turns russet, gold, and scarlet, while Mount Rainier shines more purely after a fresh snowfall on its heights. The mountain has twenty-five major glaciers and many nameless snow or ice patches covering about thirty-five square miles. When you walk anywhere near Paradise the mountain takes up your entire view, encompassing head-on and peripheral vision. Every time I approach the Nisqually River bridge in the park, I marvel, just as early visitors did: The mountain is impossibly huge!

I visited the Paradise meadows in August on an overcast day, but it only made the flower colors glow more intensely. The meadows are populated by subalpine firs (*Abies lasiocarpa*) and the most open and sunny areas are blanketed by a beautiful shrub called rosy spiraea (*Spiraea densiflora*).

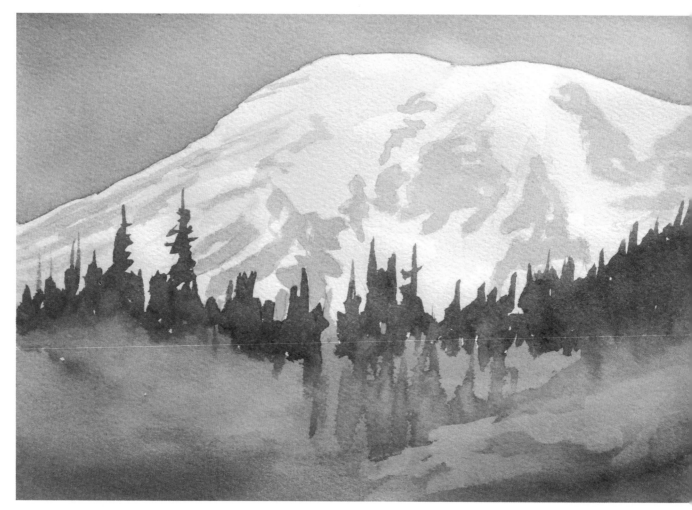

Mount Rainier and Paradise Meadow in autumn

Autumn Sketchbook Hike to Paradise Glacier

The colors of the meadows at Rainier in September are about as stunning as the flowers of July and August. And in fall one has the sense of impending winter and months of gray skies in the Pacific Northwest. Like the marmots collecting meadow greens for their dens, we hurry, gathering and storing memories.

Starting out at Paradise and heading east on the trail on a clear fall day, we joined the Skyline Trail and quickly came to Myrtle Falls, a beautiful waterfall that flows from Edith Creek, a tributary of the Paradise River. The autumn colors were warmed by the cool hues of the water and the mountain's new coating of snow. There was still water rushing down in long fingers after a dry August.

Descending a little we strolled through meadows where paintbrush was blooming. On a steep slope, talus spread out for several hundred feet. Several marmots perched atop some jagged boulders. A very young one scurried beneath one of the boulders. Below us, mountain hemlocks (*Tsuga mertensiana*) and Alaska cedars cast cool shadows across the blazing huckleberry shrubs.

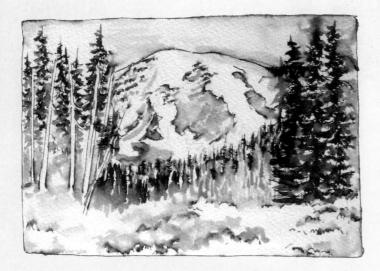

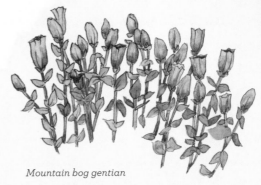

Mountain bog gentian

The mountain bog gentian (*Gentiana calycosa*), found in watery meadows in the park, thrives in moist locations like the lower Sluiskin Falls of the Paradise River, creating a luxurious splash of rich, deep blue-violet in early autumn.

You may find amanita mushrooms glowing orange and gold in the shade of subalpine firs at the park. In spite of its delightful appearance—the sort of mushroom an Alice in Wonderland caterpillar might choose to perch atop—*Amanita muscaria* is potentially poisonous. It usually pops up after the first rains of fall, growing in the shade of conifers.

Amanita mushroom

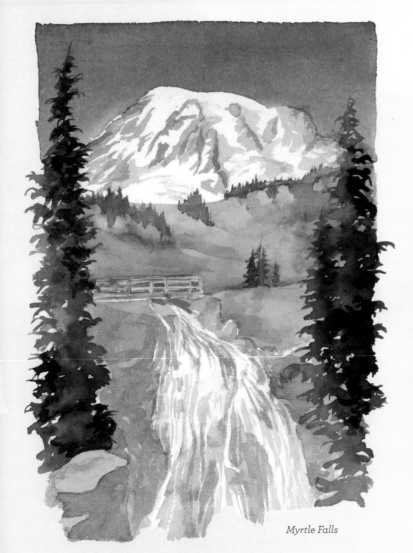

Myrtle Falls

After rounding the bend below the lower Sluiskin Falls we encountered what I think of as the Stevens/Van Trump/Sluiskin Memorial Bench; it honors the first known ascent of Rainier by settlers. It's a rather awkward-looking monument, almost an anti-monument, but fits into the landscape of scree and talus. The inscription reads: "Site of the camp from which General Hazard Stevens and PB Van Trump made the ascent of this mountain 17 August 1870." Also: "Sluiskin Indian Guide waited here for the climbers to return." And, "Place identified by General Hazard Stevens 17 August 1915." And, "Erected by the Mountaineers and the Mazamas, 1924." As a matter of fact, Sluiskin, a very able guide (without whom they might never have located the route) and hunter, did not wait idly for them to return, but spent the three days hunting mountain goats (*Oreamnos americanus*).

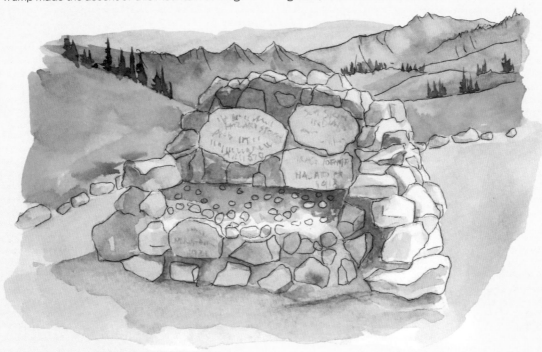

Stevens–Van Trump Historical Monument

As we hiked higher and higher, we reached the upper limits of the tree zone. I discovered a beautiful alpine lady fern (*Athyrium americanum*) turning golden among the rocks in the autumn light. According to Biek's guide, this fern is common on open rocky slopes and moraines above 5,000 feet. We spotted it near Sluiskin Falls at 5,400 feet. You may also see it on talus slopes above Owhyhigh lakes, on Seattle Peak at 5,000 feet, and at Eunice Lake. The plants can get as large as three feet, but in exposed places they're usually no more than six inches.

Meanwhile, hoary marmots (*Marmota caligata*) were everywhere gathering food. Marmots don't store food during the winter; they are true hibernators and enter winter torpor, so the intense food gathering must have been a form of carb-loading.

The autumn view at the base of the Paradise Glacier, on the Paradise Glacier Trail, puts one in mind of Mars, the red planet. There are no trees and nothing green in sight. Only rocks of the volcanic hues, pink and gray, the blue sky, and the white of the glaciers beyond. Earlier in the year the lingering snow gives the scene a more pristine character, but in the fall the colors of the grasses and lichens burn in changing hues of gold, olive, and orange against the sky.

Alpine lady fern

Autumn view from Paradise Glacier Trail

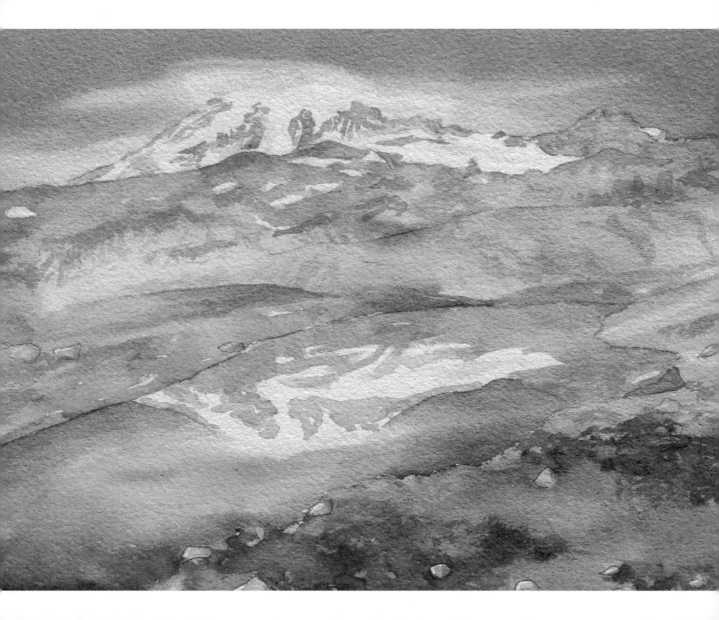

HOARY MARMOT (*MARMOTA CALIGATA*): A PLAYFUL SOCIETY

The hoary marmots of the Cascade Range and the Olympic Mountains are the most sociable of all the species descended from a common ancestor. These species include woodchucks, which are quite solitary and aggressive and only socialize when mating and raising young. Marmots, on the other hand, are not as territorial. Their relationships do not depend on dominance. One likely reason is the harshness of their subalpine environment. The young need to be cared for beyond the first season so that they can acquire the necessary body fat reserves they require to thrive as adults. The very cooperative life in a marmot colony gives the young the necessary time to reach maturity. It makes me wonder: Do we become less caring of our fellow beings the more ease and luxury we enjoy?

In early August, entire colonies of marmots are out foraging, playing, and sunning themselves all around the park. One particular area, a large talus field just below Myrtle Falls on the Skyline Trail, harbors a large group. The mature marmot I sketched seemed to be doing sentry duty. Nearby, young marmots were engaged in a mock battle. About a month and a half later, along the trail to the Paradise Glacier, I saw about thirty marmots of all ages. It turned out to be the last nice day of the year. How did they know to make such a day of harvesting? They were all out gathering vetches, sedges, and fescues and seemed to take no notice of us at all. The day after our visit, it rained and snow came very soon after that. There were no more fine days!

Hoary marmot adult on sentry duty

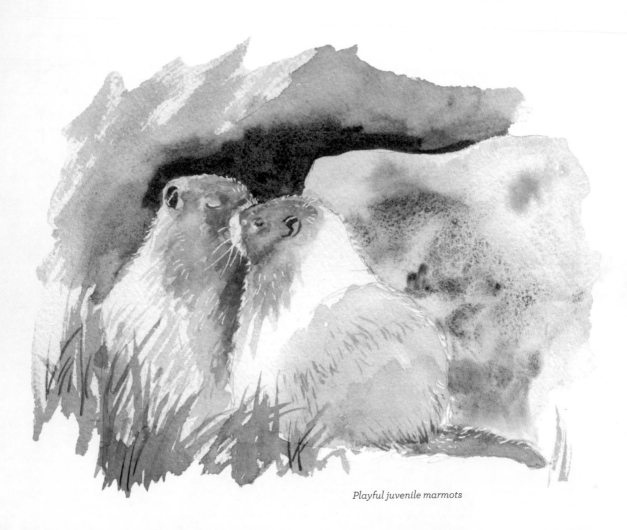

Playful juvenile marmots

Stevens Canyon

Stevens Canyon is a deep, glacier-carved U-shaped valley on the southeast slope of Rainier. The size and scope of the canyon is breathtaking as you round the hairpin turn heading east above Louise Lake and just below Bench Lake. Stevens Canyon Road was begun in 1931, but work was halted during World War II. In 1950 construction resumed. The engineering was an impressive feat: the road crosses several creeks and rivers and skirts a couple of dramatic waterfalls as well, as it connects the south and east sides of the park. The road finally opened to the public in 1957. Enabling automobile travel all the way around the park was one of Mather's goals, one idea being that it would disperse visitors so that Paradise would not be so overrun—the crowds there are not just a recent phenomenon—but the entire circuit was not completed.

Reflection Lakes are perhaps among the most photographed sites in the park. Going early in the morning gives you the best chance of unruffled waters for a perfect reflection of Rainier. In late July the spiraea is blooming all along the lake's edge and makes a lovely frame for the view.

The two small lakes were formed after the huge Paradise Avalanche swept into the area about 5,700 years ago. It stopped at the north side of the Tatoosh Range, creating a dam, which stopped the waters that became the Reflection Lakes.

I stopped for this view of The Castle (left) and Pinnacle Peak (page 62) on an early summer day in June, when snow still reached to the Stevens

Pika

Mount Rainier from the Reflection Lakes

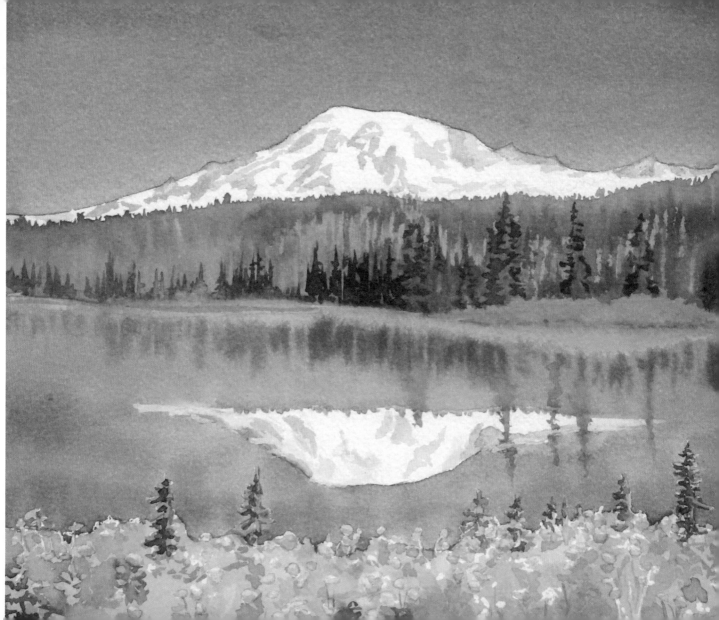

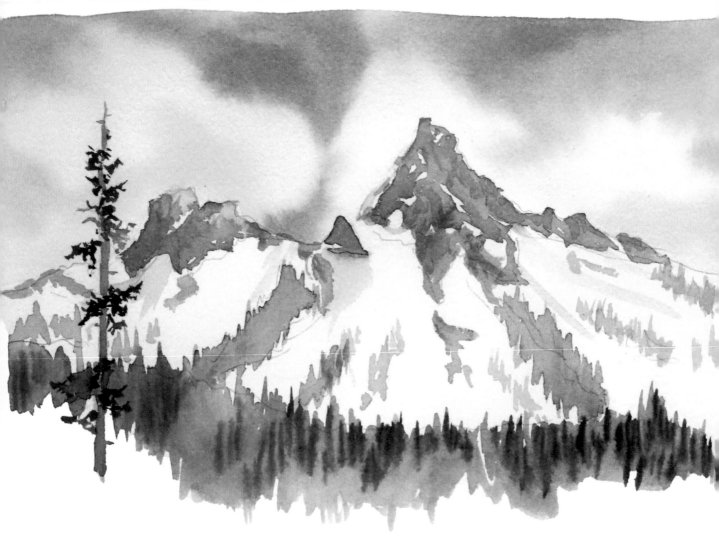

The Castle and Pinnacle Peak

Canyon road. The Tatoosh Range, which includes fourteen jagged peaks south of Paradise, is almost entirely within the boundaries of the park. The height of these peaks averages about 6,000 feet, and the bases of most of them are easily reached by trails. Unicorn Peak, The Castle, and Pinnacle Peak are popular with climbers.

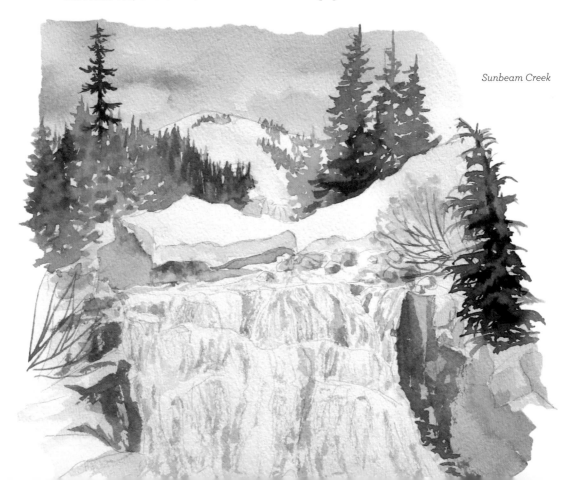

Sunbeam Creek

Sunbeam Creek, the source of the park's Lake Louise, doesn't fall steeply or long, but it called out to be sketched on an early June day, with willows coming into leaf along its banks. The creek is just south of the highway and I would have missed it entirely had I not noticed the avalanche lilies blooming beside banks of melting snow. Snow doesn't linger so late in most years, but it was a cool spring and summer was delayed.

Avalanche lilies are dominant in subalpine meadows, and they are the first to bloom in spring when snow is melting. I saw these graceful nodding flowers near Reflection Lakes and all along the road near Stevens Creek in June. It can take years for a plant to grow from naturally dropped seed until it blooms, one very important reason not to trample meadows. The blooms are so delicate as to be almost translucent, and they fade to pink with age.

Avalanche lilies

Later in July the canyon area meadows become very colorful. Right outside the car, broad ribbons of scarlet paintbrush (*Castilleja miniata*) extended alongside the road. Then when I hiked to Snow Lake and Bench Lake nearby, the trail was decorated with wands of beargrass (*Xerophyllum tenax*), and scarlet paintbrush bloomed everywhere.

Paintbrush and Rainier from Stevens Canyon Road

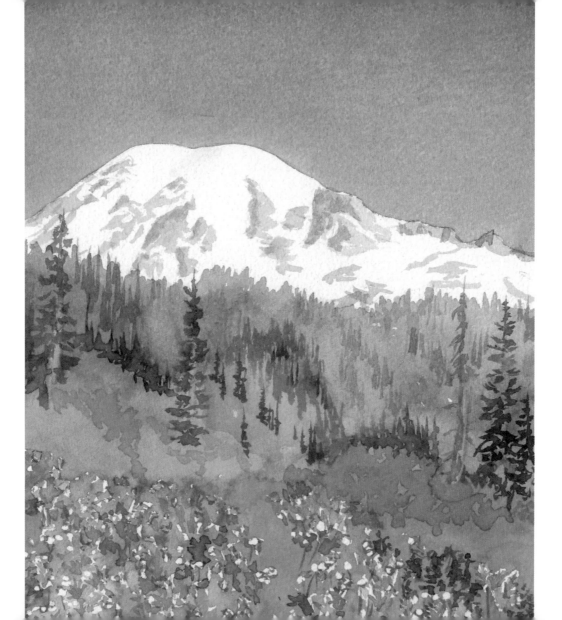

Farther down the Stevens Canyon Road, look down 180 feet to the Muddy Fork of the Cowlitz River as it flows in a slot canyon only thirteen feet wide. It is rare to see a bridge and tunnel so close to each other and both are remarkable—the bridge is so tightly bound to the cliff edges that you might not even realize there is river below, and the tunnel bores directly into the mountainside without any masonry portals on either side. It's like going into the hall of the mountain king! I was very keen to go down to take a closer look at the Muddy Fork and the canyon, but I learned that there was no way down to the river short of donning climbing gear and rappelling.

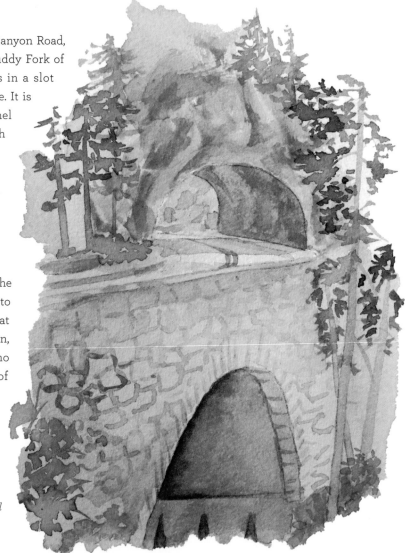

Muddy Fork Cowlitz bridge and tunnel

CASCADE RED FOX *(VULPES VULPES CASCADENSIS)*: HAUNTS ON ICE-BOUND CLIFFS

These arctic forms are as effectually isolated as shipwrecked sailors on an island in mid-ocean. There is no refuge for them beyond their haunts on ice-bound cliffs.

—BAILEY WILLIS, MEMORIAL FROM THE GEOLOGICAL SOCIETY OF AMERICA, 1893

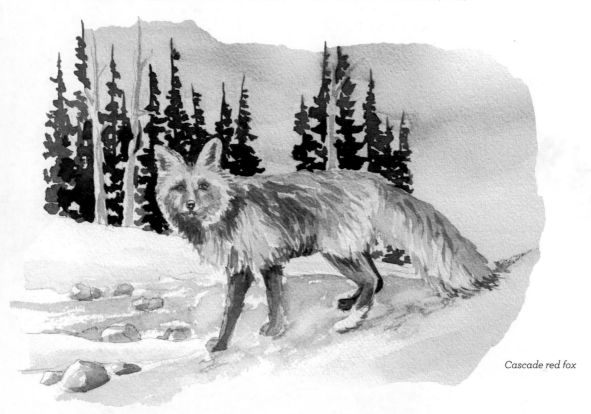

Cascade red fox

The wet and slightly bedraggled-looking dark fox with one hind white paw paused beside the road just below Paradise. I assumed it was watching me, waiting for me to drive on so it could cross the road. Heavy wet snow was falling. "Poor fox," I thought. What a hard winter it must have been with the snow lingering so much longer than usual. Congratulating myself for visiting mid-week and avoiding the crowds, I figured I was getting a rare glimpse of wildlife, but wondered why it looked so different from typical red foxes.

It turned out that I didn't really know what I was looking at. It was no common fox, but a Cascade red fox. "Red fox" seems like a misnomer for this individual because it had black fur with some gray grizzling on its back, but red foxes can vary in coloration. Black and gray is simply one of their "color phases." The Cascade red fox, whose populations have been documented from Mount Rainier south to Mount Adams, is one of four subspecies of montane red fox (or mountain foxes) in the United States. The Rocky Mountain red fox (*Vulpes vulpes macroura*), which I once saw in Yellowstone, is fairly widespread in the Northern Rockies. They, too, vary in color and aren't all red. There is also the montane red fox of the Sierra Nevada (*Vulpes vulpes necator*). A fourth subspecies, called the Sacramento Valley red fox (*Vulpes vulpes patwin*), was recently discovered; it lives at low elevations in central California.

The lineage of the mountain foxes is fascinating. They came over to North America from Asia across the Bering Land Bridge during the second-to-last or Illinoian glacial

stage, 300,000 to 130,000 years ago. During the Sangamon interglacial period, 130,000 to 100,000 years ago, these red foxes expanded their range southward into the contiguous United States, where they became isolated from other populations in North America during the most recent or Wisconsin glaciation, 100,000 to 10,000 years ago. When those glaciers retreated, warming climatic conditions forced them to follow their preferred habitat conditions up into the high elevations of the western mountains.

Dr. Keith Aubry, biologist emeritus with the US Forest Service in Washington, was the first researcher to study the Cascade red fox in detail. He discovered major differences between the mountain foxes of the western United States and those of neighboring populations in Canada, which had been genetically isolated from the mountain fox lineage for almost half a million years. People have wondered why the widespread lowland foxes do not interbreed with the Cascade red fox, since it is easy for them to head up highways to the mountains. Modern DNA testing has shown that the Cascade red fox is unique. They are adapted to a cold and demanding climate. Scientists have speculated about whether they have a cold tolerance in their mitochondrial DNA, which affects their metabolism.

During his field studies in the early 1980s, Dr. Aubry observed only a single Cascade red fox on Mount Rainier, at Sunrise. But they have been sighted frequently in the past decade near Longmire, Paradise, and Sunrise, and are even known to den nearby. Visitors are interacting with them and feeding them, an unhealthy situation for both humans and foxes.

While their abundance is unknown, Dr. Jocelyn Akins, conservation director at Cascades Carnivore Project, guesses there may be fewer than two hundred Cascade red foxes in Washington's South Cascades, including Mount Rainier. Elsewhere in the Cascades they are even more rare. When I sent her my photo, she replied right away—it was "the (in)famous Whitefoot," one of two or three habituated red foxes at Mount Rainier. And so, what I thought of as a lucky encounter was not so unusual! And perhaps Whitefoot was watching me for reasons other than waiting to cross the road. I am still grateful to have seen her, since she represents a rare species that has found refuge at Mount Rainier. And for her making me aware of the valuable work of the scientists and organizations that help us understand the importance of habitat preservation.

Ohanapecosh

At 1,914 feet elevation and in the southeast part of the park, Ohanapecosh is relatively warm and free of snow. Archaeologists have recently discovered that the area has a long history of use by Native peoples. In 2015, at the current campground they discovered the first ever low-elevation cache of materials within the park—chipped stone tools and the remains of a hearth—which they dated from 6,400 to 3,700 years ago. The guess is that the site was a way station for people making trips from their winter lowland homes to higher elevation summer sites for hunting and berry gathering.

In the early 1900s, soon after the park was established, various entrepreneurs created tent camps and even a resort with a hotel near the Ohanapecosh hot springs. Visitors would travel up from the town of Packwood, because there was no road from the west side of the park at that time. These tent camps and hotels, bathhouses and cabins didn't thrive financially and soon became a dilapidated eyesore and an embarrassment to the park. The owner was bought out in 1961 and the buildings were torn down. At that time the hot springs were restored to their natural state, and bathing was no longer allowed. Now, there is a visitor center, campground, and not-to-be-missed forest, more than a thousand years old, on an island in the middle of the river.

I picked up the Silver Falls Trail along the river right out of the visitor center and almost immediately found the hot springs. The most prominent one, a terraced spring, flowed just above the trail, but on a short spur trail there were other red-tinged pools, surrounded by delicate grasses common to the areas around hot springs, most likely *Dichanthelium acuminatum*. The trail is without too many ups and downs, perfect for families, or for hot days when further exertions are out of the question. The day I visited, the high temperature was forecast to be 99 degrees Fahrenheit, but I didn't

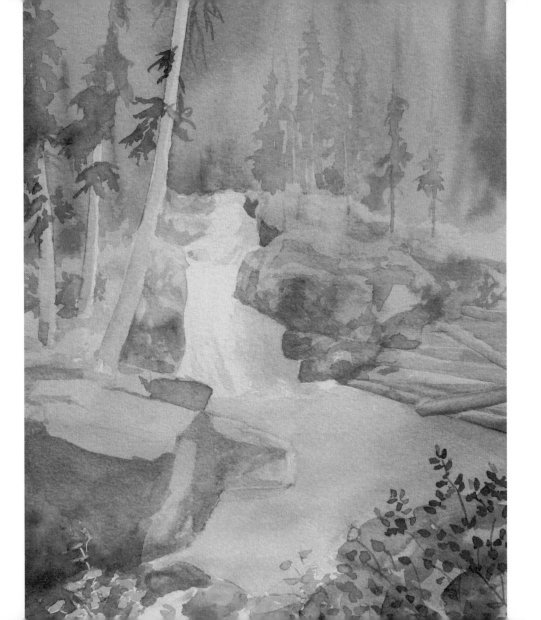

feel the heat at all in the shade of the forest, since stately old-growth trees line the trail. The falls are a little less crowded than the Grove of the Patriarchs, and the turbulent white water plunging forty feet into a turquoise pool is a marvel well worth seeing.

Some of the trees in the grove are more than 1,000 years old and dwarf human visitors. I drew a sketch of twin Douglas-firs to share with my twin sister! Several of the trees are over twenty-five feet in circumference, and one is almost fifty feet. Even the fallen trees in the Grove of the Patriarchs are enormous. The twists and turns of a fallen cedar reminded me of the river that surrounds this island forest. Because the narrow swinging suspension footbridge across the Ohanapecosh River can only support two people, visitors wait to cross. That patience puts us in the proper solemn frame of mind when we finally enter the ancient grove. It is thought the trees in the grove survived these centuries

Twin Douglas-firs (sketch)

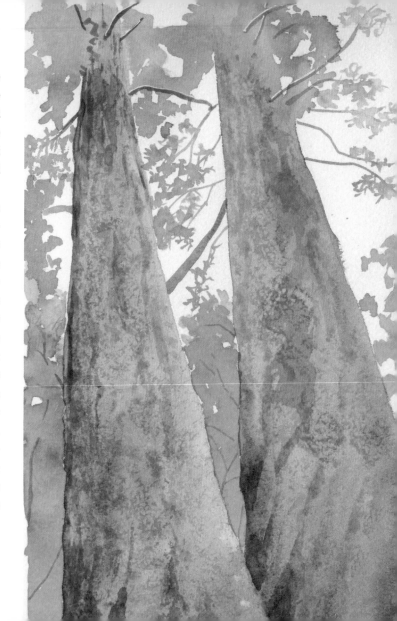

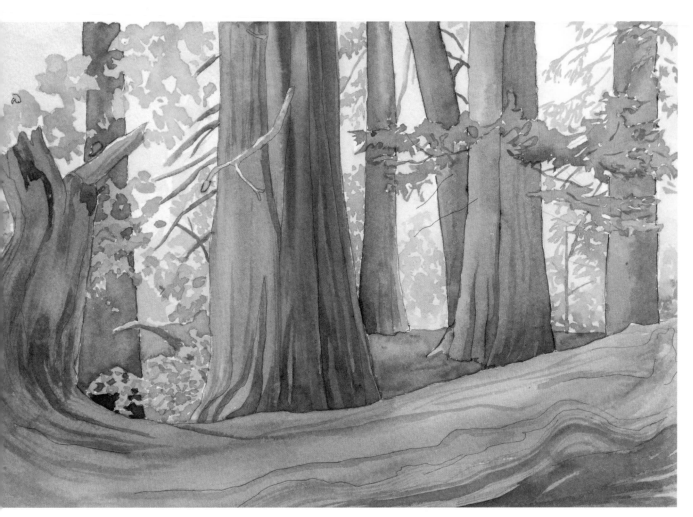

Grove of the Patriarchs, Ohanapecosh

because they were on an island and were protected by the river during fires that destroyed other forests. It is an unusual place for an old-growth forest, since it is situated in the comparatively dry southeast corner of the park.

This view of the river is gained from the trail to the grove. The Ohanapecosh River is one of only two rivers in the park that flow not into Puget Sound but rather into the Cowlitz River that then flows into the Columbia River to the south. Its waters are remarkably clear and blue-green because they don't originate in a glacier. Ohanapecosh, which is the Upper Cowlitz or Taidnapam name for the river, has several possible meanings: "standing at the edge-place," "clear stream," "deep blue," or "deep holes."

Western hemlock and Ohanapecosh River

NATIVE AMERICANS AND MOUNT RAINIER: TAKHOMA

*I believe in the sun and the stars, the water, the tides, the floods,
the owls, the hawks flying, the river running, the wind talking.
They're measurements. They tell us how healthy things are.
How healthy we are. Because we and they are the same.
That's what I believe in.*

—BILLY FRANK JR., NISQUALLY TRIBAL LEADER

One of the oldest archaeological sites on Mount Rainier is at Buck Lake, where evidence of Native American use dates back at least as far as 7,400 years. A kind of carving tool was found buried beneath layers of volcanic debris that piled up during the eruption of Mount Mazama in Oregon. Hunting artifacts were also found in a rock shelter near Fryingpan Creek. This site was most likely used by one of the Columbia River Plateau tribes. Until the arrival of European settlers, Yakama, Taidnapam (Upper Cowlitz), Nisqually, Mashell, Muckleshoot, and Puyallup tribes made annual visits, according to Allan Smith's groundbreaking study *Takhoma: Ethnography of Mount Rainier National Park* (Coast Salish tribes, like the Puyallup and Nisqually, among others, used some form of "Takhoma" when they referred to Rainier.) He wrote that many tribes visited the park late each summer for berry picking and hunting. He originally thought they stayed a week but since he completed his work in the 1960s,

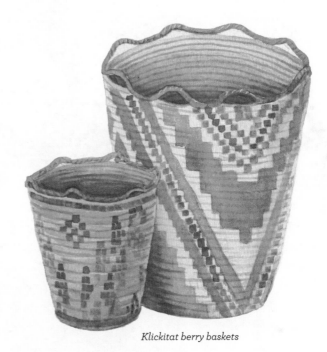

Klickitat berry baskets

further research has indicated that the groups stayed at least two weeks, and generally in August and September when the huckleberries ripen.

There are about ten varieties of huckleberry or blueberry, all belonging to genus *Vaccinium*, at Rainier, but the tribes seemed to focus on picking blueberries (*Vaccinium deliciosum*), which were especially large and kept very well. Women and children participated in the essential task of berrying and used collecting baskets, often hung from their waists, for harvesting. The conical baskets were inventively designed so that the berries at the bottom would not be crushed. The coils were made from cedar roots, and the pale colors in the imbricated designs were created with beargrass. It took up to three months to make a berry basket, and they were highly valued among the tribes. One basket was considered to be worth as much as a horse. Baskets used for other purposes were made solely of beargrass and similarly prized. Floyd Schmoe wrote that these baskets "hold water and are used in cooking and [are] so durable that I have seen specimens that were still in use after being handed down for three generations."

The Taidnapam, Nisqually, Puyallup, and Muckleshoot used mat-covered racks for drying the berries: the Nisqually mats were made of split cedar roots and cattails woven with cedar bark. The Muckleshoot mats were four feet wide and used split cedar woven with inner cedar bark. Two small fires were built under the racks, and once the berries

Beargrass in bloom

were dried, they were stored in baskets. Later they were boiled to be reconstituted. The racks were rolled up at the end of the picking season and hidden until next year's berrying. The Yakamas did not use racks. They built a large mound of earth and covered a side of it with mats, then spread the berries and set small fires in front of the mounds. According to Native sources, some Yakama women managed to harvest fifty pounds of the dried berries in one season.

Many animal species were also attracted to the ripening fruit, so there were ample hunting opportunities for fur and meat, which would also be dried for winter consumption. Men hunted mountain goats, notably difficult to pursue. The fur of the mountain goats was very useful for clothing. In addition to goats, the men hunted deer, elk, and some tribes hunted bear, although the Yakama people refrained because of guardian spirit restrictions.

The tribal groups that made use of Rainier's bounty prospered, and this bounty caused other lowland tribes to seek them out for trade: blueberries, elk and deer meat, and goat and other furs were all traded. A Taidnapam tribe member said that often

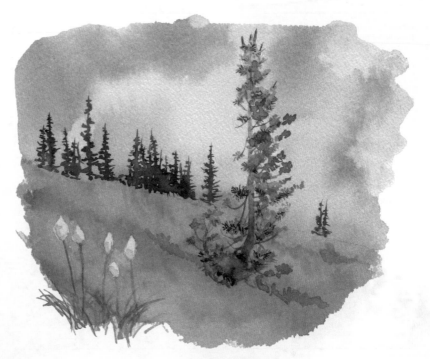

Beargrass and whitebark pine (sketch)

the lowland tribes would trade women and men for food (though they were not happy about having to do so). The intermarriage resulted in some mixes of language and people. Some anthropologists speculated that this intermarriage happened after contact with Europeans, but evidence and Indian informants lead many to believe that this was a centuries-old form of trade.

The White River & Sunrise

The White River gets its name from the suspended glacial sediment that runs off from the Emmons, Fryingpan, and Inter Glaciers, which mill the underlying volcanic rock into a fine flour. This popular northeast entrance to the park leads to the White River Campground, established in 1921, and then farther on to the Sunrise area at 6,400 feet. The lower elevation forests are Douglas fir and western hemlock, with the understory characterized by vanilla leaf. This unique part of the park is drier, being in the volcano's rain shadow. In addition, much of the pumice from previous eruptions settled on the east and north sides due to the prevailing winds, so the soil drains quickly and becomes even drier as the summer progresses. Plant species from the east side of the Cascade Range live here, and it is thought some of the rarities are relics from a time when climatic conditions were much drier on the west side of the Cascades, perhaps 6,000 to 8,000 years ago. For example, above the White River Campground, Engelmann spruce grows. Even more unusual are the ponderosa pine individuals that grow at around 4,000 feet on the road to Sunrise. As you drive up from the White River, you will see the forest change to mainly noble fir (*Abies procera*) and then to subalpine fir (*Abies lasiocarpa*). At Sunrise Point you will be

Ponderosa pinecone

Mount Rainier from Glacier Basin

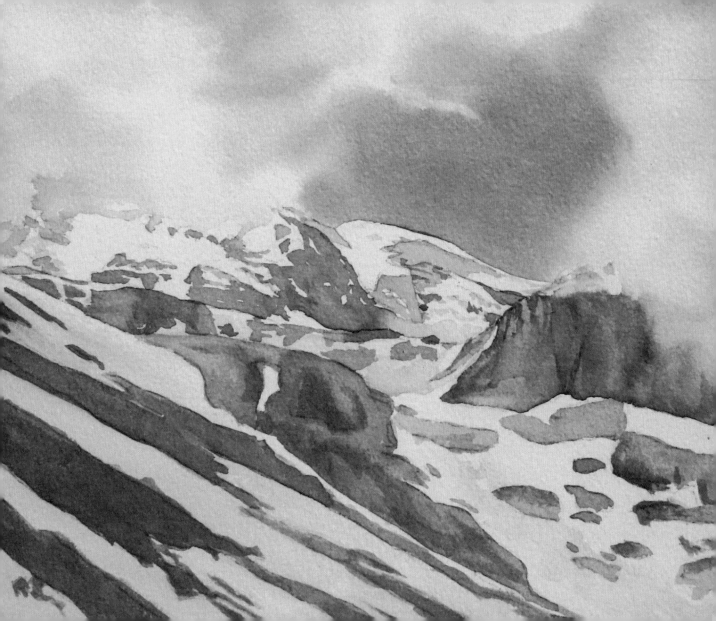

at 6,100 feet, which is near timberline. Above this there are some isolated clumps of subalpine fir, mountain hemlock, and whitebark pine (*Pinus albicaulis*), as well as windswept Alaska cedar groves. The Sunrise Visitor Center is at 6,400 feet, almost 1,000 feet higher than Paradise. The soil is composed of many pumice deposits from volcanic eruptions, including most recently Mount St. Helens (in 1980), and in the distant past, Mount Mazama (7,700 years ago), whose eruption formed Crater Lake in Oregon. The fast-draining soil on the White River side supports many species of wildflowers but perhaps many more grasses and sedges; plant life is characterized by green fescue and several aster species. As you ascend toward Sourdough Ridge, the plants quickly give way to alpine and tundra-like species.

At Glacier Basin, Rainier's summit (14,411 feet) is far above, partially blocked by Curtis Ridge, although you can see Liberty Cap, a subpeak of Rainier close to the summit, glowing pristine white against a deep blue sky in the distance. Timberline is a few hundred feet higher than the basin, and beyond that the views are positively Himalayan, with gleaming glaciers, clouds swirling in the heights, and fearsome cliffs and rocks surrounding St. Elmo Pass. The pass was given this name by Major E. S. Ingraham in 1887, when he and a party of climbers were camped on the ridge that divides the Winthrop and Inter Glaciers and encountered an electrical storm. Mount Rainier National Park's *Nature Notes* of August 1929 describes what happened next: "During the night they were startled by the St. Elmo fires (an electrical phenomena)" which lit "up the metal of their alpenstocks and cooking utensils, and so Major Ingraham named this ridge and pass 'St. Elmo.'"

The Silver Forest Trail at Sunrise is a quiet walk along the rim of the White River valley. You quickly encounter the namesake trees, bleached and dead tree trunks and snags, with a beautiful silver hue, set off by the deeper greens of whitebark pines (*Pinus albicaulis*) and subalpine firs. There are other silver forests at Rainier—the

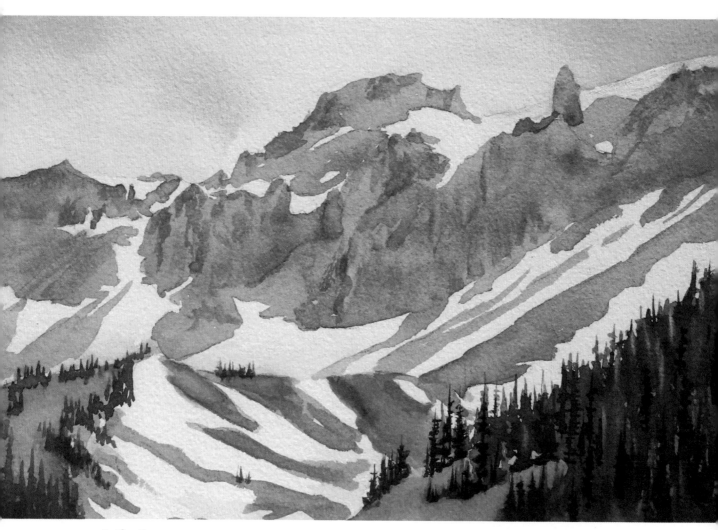

St. Elmo Pass

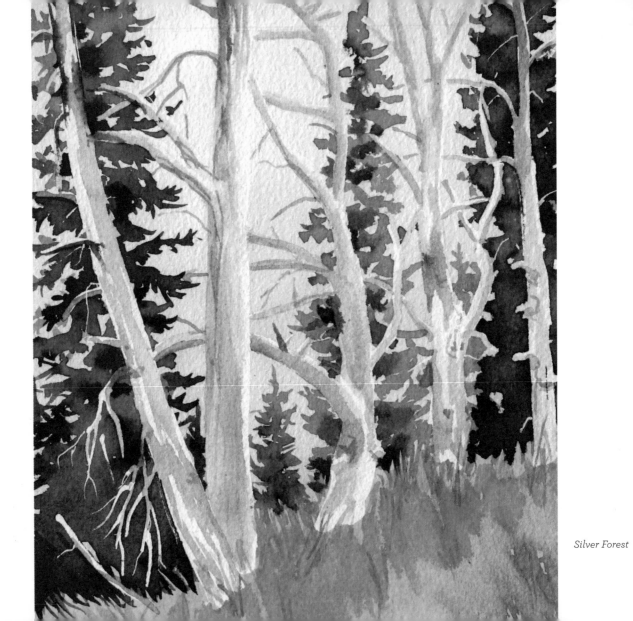

Silver Forest

results of forest fires and other natural events. The Kautz Mudflow in 1947 resulted in a recent silver forest. The meadows of the Paradise area were created by a forest fire, which left many dead Alaska cedars. After decades of weather exposure, the trees take on a silver patina like ocean driftwood.

> *From the dense forests of the valleys and on the lower slopes where trees grow to a height of over 300 feet and some with a diameter of 12 feet, the forester can trace the diminution of growth as the ascent is made to the scrubby brushlike trees at timberline, struggling as it were for their existence. They are gnarled and twisted as if they had endeavored to escape the fury of the fierce blasts that sweep over the upper slopes.*
> —STEPHEN MATHER

Whitebark pine is an early colonizer in the mountain hemlock zone, especially on the east side of the park. Shrubs in this zone include huckleberry and Cascade azalea, and herbs include Sitka valerian and avalanche lily, although they do not grow as profusely as they do in meadows on the south and west sides. Dwarf forests of whitebark pines with junipers (*Juniperus* species), stunted and battered by extremes of wind, snow, and cold, can be found on ridges above Yakima Park at Sunrise.

Along the Silver Forest Trail, I saw a group of three different tree species: an Alaska cedar, a whitebark pine, and a subalpine fir. It was obvious they were helping each other to survive, since they huddled so closely together. In the inhospitable conditions at the elevation of Sunrise, whitebark pines are often the first to grow in a meadow. Once they have created some shelter, other species, like the cedars and subalpine firs, can join them.

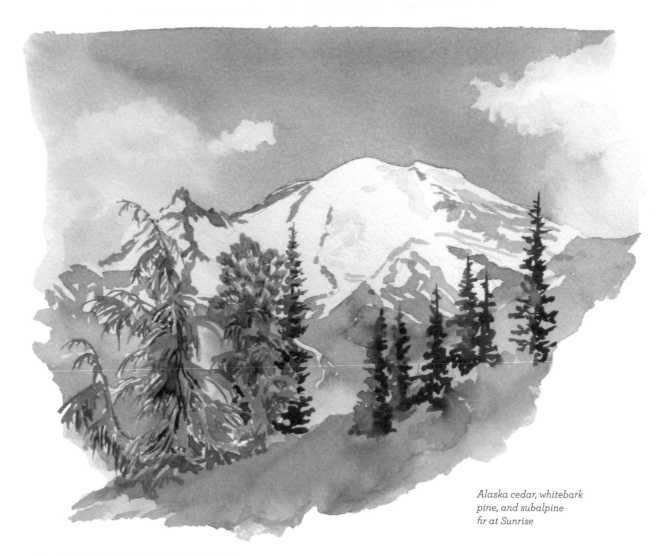

Alaska cedar, whitebark pine, and subalpine fir at Sunrise

Arriving at the Sunrise Visitor Center one July right after a month of forest fires in the Cascades, I was stunned by the perfectly clear air, which had not been seen in Seattle in many weeks. A heavy rain the day before may have cleared the pollens and smoke from the skies. As I looked hundreds of yards ahead of me, each subalpine fir was crisply outlined, each branchlet clearly defined with its bright green new growth. Yes, I had just gotten a pair of new glasses, with a new prescription and without my old pair's scratches and dirt. But this was an extraordinarily clear day.

My husband spotted a beautiful Edith's checkerspot butterfly along the Silver Forest Trail. Its Latin genus name (*Euphydryas*) means "shapely dryads," or nymphs. The checkerspots really do have a kind of checkerboard pattern on their wings, unlike the fritillary butterfly, which they resemble and are mistaken for.

Edith's checkerspot

Arctic fritillary

Sunrise is situated in what was known as Yakima Park. It was the third and last development of facilities in the park and was begun in the 1920s. A major hotel was planned as part of the lodge complex but the Great Depression made it difficult to begin the lodging portion of the development and it has never been built. At 6,400 feet elevation, it was important to take into consideration the fragile subalpine ecosystem, and the master plan for the complex designed by architect Ernest A. Davidson carefully minimized the impact. Unlike the other areas in the park, this one was designed all at the same time coherently in the rustic style, specifically a frontier blockhouse and stockade. The designs were completed by architect A. Paul Brown. It took decades to finish the complex: the stone and timber fireplace in the visitor center was not finished until 1952.

The visitor center has a telescope where you can watch climbers ascending Rainier via the Emmons Glacier route. There is a replica of the mountain with its glaciers named, plus a collection of taxidermied common birds and mammals of the park, a rather old-fashioned exhibit that our children nevertheless always enjoyed.

I appreciate the approach to the visitor center, fronted with an alpine garden of wildflower species and trees—evidence of how carefully the site was planned to accommodate the plants of the surrounding meadows. The scale of Sunrise is smaller than Paradise and it feels welcoming.

Sunrise Visitor Center

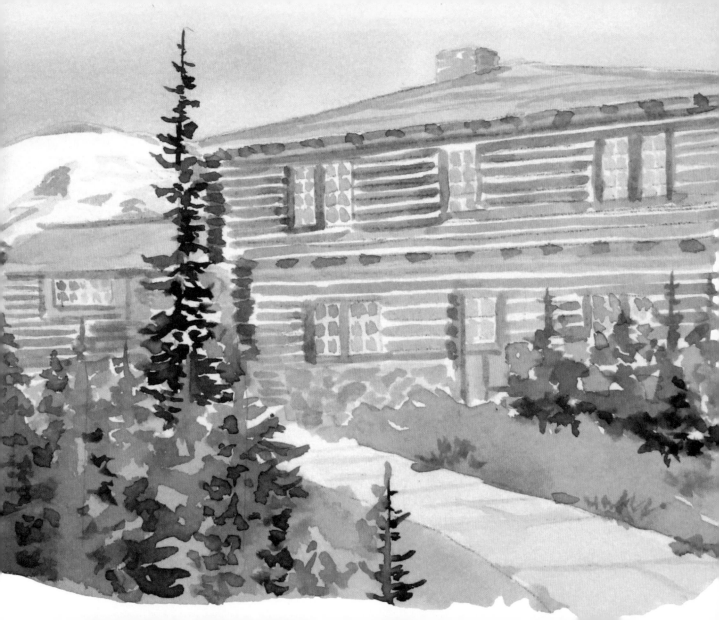

Not too far above Sunrise, on a slight detour to the south of the Wonderland Trail, is rocky Burroughs Mountain, home to mountain goats (*Oreamnos americanus*) and fascinating tundra plants.

In late September at Sunrise and beyond it along the Wonderland Trail, most of the forbs (flowering herbaceous plants other than grasses) have died back and the land has a dry and desiccated aspect—just heaps of pumice and other volcanic debris strewn about with the wonderful exception of Newberry's knotweed (*Aconogonon davisiae*). This plant isn't particularly inspiring when it flowers, but its fall color is startling and it grows everywhere near the trail. It is a rapid colonizer in high-elevation disturbed soils. American bistort, another common flowering mountain plant of the same genus, is really lovely when flowering, its modest white flowers scattered widely like little beacons shining among the more colorful flowers in a meadow.

Mountain goat

Newberry's Knotweed and Mount Rainier

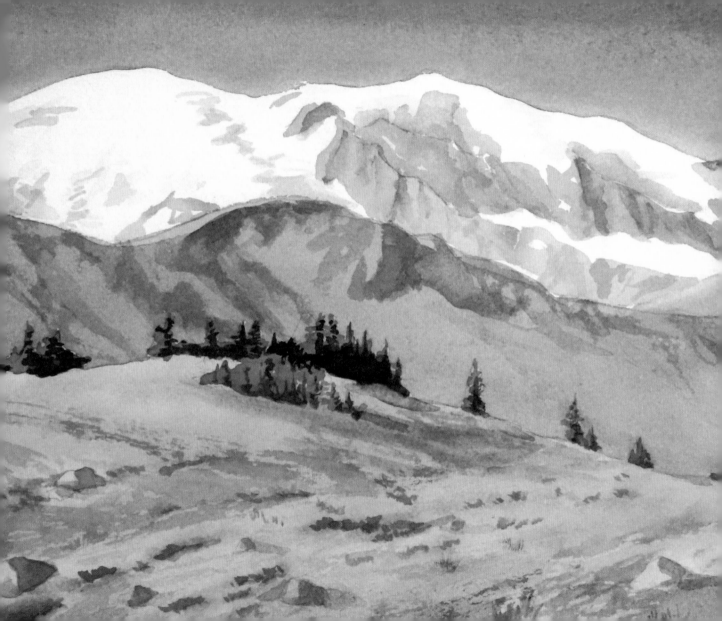

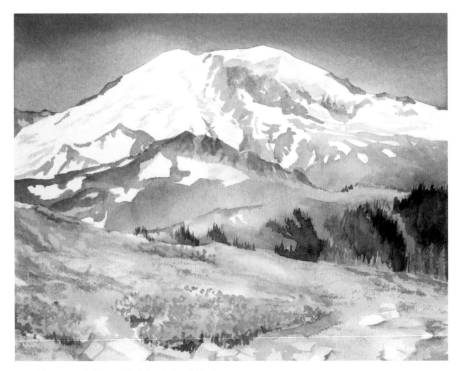

Shrubby cinquefoil near the Wonderland Trail

I was really surprised the first time I saw dazzling shrubby cinquefoils (*Potentilla fruticosa*), lying matlike along the trail in the volcanic soil that doesn't support a lot of other plant life at this high elevation. Shrubby cinquefoil is grown in gardens all over the West. It likes dry conditions and doesn't need a lot of upkeep. In urban lowland gardens it is larger and taller than the cinquefoil at Rainier, but nowhere in town would you see such a spectacular backdrop.

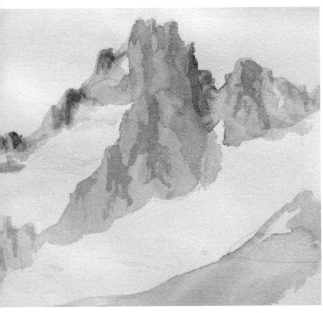

*Little Tahoma
from Skyscraper
Mountain*

The ever-present golden-mantled ground squirrels (*Callospermophilus saturatus*) at Sunrise are a native species quite common all over the park and not shy around visitors. This individual was watching a group of teenagers eating their lunches near Frozen Lake above Sunrise. I wondered why the squirrel had no interest in me, but perhaps it understood that the chattering, playful young human beings might be a little more careless with their food.

I took a really fine photo of Little Tahoma from the trail up Skyscraper Mountain—possibly the best view of it from anywhere in the park. I was about three-quarters of the way up the mountain and decided that was far enough.

On the way down I decided to stop again and draw Rainier. From this point on the Wonderland Trail, it is so enormous that it took up an entire two-page spread in my sketchbook.

*Golden-mantled
ground squirrel*

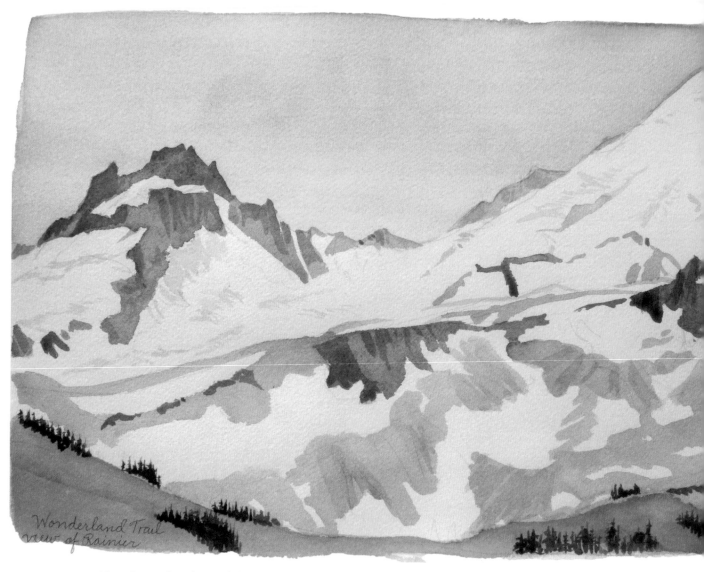

Mount Rainier from the Wonderland Trail near Berkeley Park (sketch)

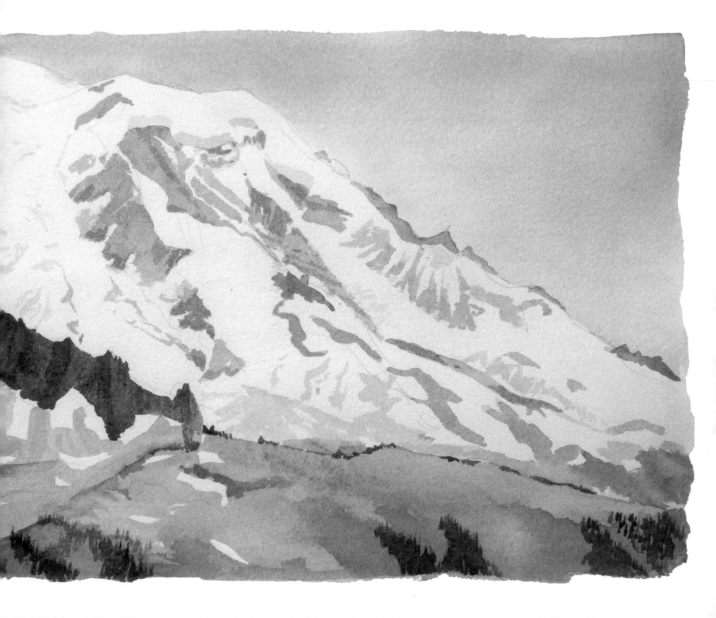

Summer Sketchbook Hike to Glacier Basin

The emptiness and silence of snow mountains quickly bring about those states of consciousness that occur in the mind-emptying of meditation, and no doubt high altitude has an effect, for my eye perceives the world as fixed or fluid, as it wishes. The earth twitches, and the mountains shimmer, as if all molecules had been set free: the blue sky rings.

—PETER MATTHIESSEN, *The Snow Leopard*

Glacier Basin at Rainier makes a wonderful, not-too-difficult early summer hike. When we left one morning in July it was overcast in Seattle, and by the time we got to Enumclaw it was misting and raining lightly. Not a very promising start. Still, from experience I knew that the east side of Rainier often has surprisingly good weather, since it basks in the mountain's vast rain shadow. As we turned into the White River Entrance, the weather suddenly cleared, the sun shone, and the mountain was clearly visible, glowing above the frothy cocoa color of the White River. My spirits lifted and all my big-city worries fled with the clouds. We made a left onto the White River Campground road and I pulled over to enjoy the view of the river with the mountain looming behind.

In the early section of the noticeably easy Glacier Basin Trail, a former mining road, rather wide and not too steep, Little Tahoma rose up prominently. As we hiked above the oddly named Inter Fork, a creek below and south of the trail that feeds from the

Inter Glacier into the White River, we saw a beautiful nameless rushing torrent careening down a mossy shaded slot.

As the trail left the forest and entered sunnier slopes that were still wet from snowmelt and days of rain and clouds, magenta Lewis's monkeyflower (*Erythranthe lewisii*), named for Meriwether Lewis, and yellow monkeyflower (*Erythranthe tilingii*) bloomed lushly on the verges of rivulets and seeps. Later alongside drier areas of the trail there were large expanses of bi-colored blue and white lupine (*Lupinus* species) and some crimson Davidson's penstemon (*Penstemon davidsonii*) and a solitary and eye-catching large specimen of scarlet columbine (*Aquilegia formosa*). We walked past a row of Alaska cedars lining the trail like sentinels, rather sparsely foliaged as some are but with richly textured bark.

After climbing slightly, the trail switches back into a new section built by the Washington Trails

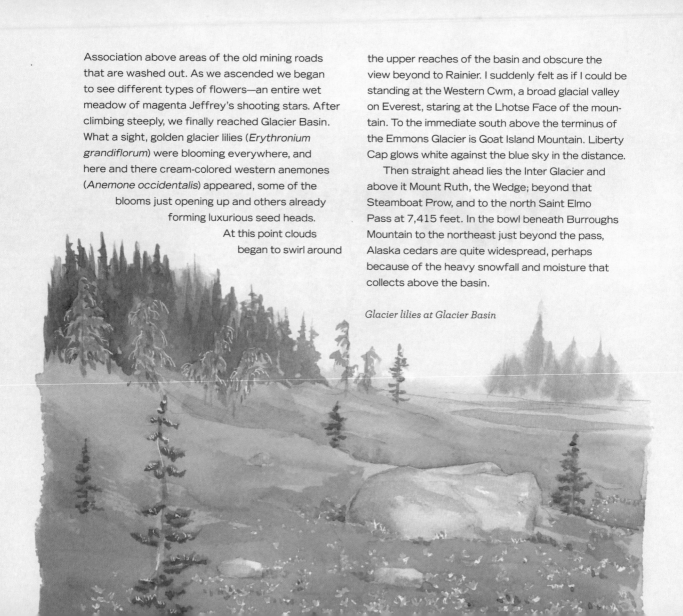

Association above areas of the old mining roads that are washed out. As we ascended we began to see different types of flowers—an entire wet meadow of magenta Jeffrey's shooting stars. After climbing steeply, we finally reached Glacier Basin. What a sight, golden glacier lilies (*Erythronium grandiflorum*) were blooming everywhere, and here and there cream-colored western anemones (*Anemone occidentalis*) appeared, some of the blooms just opening up and others already forming luxurious seed heads. At this point clouds began to swirl around the upper reaches of the basin and obscure the view beyond to Rainier. I suddenly felt as if I could be standing at the Western Cwm, a broad glacial valley on Everest, staring at the Lhotse Face of the mountain. To the immediate south above the terminus of the Emmons Glacier is Goat Island Mountain. Liberty Cap glows white against the blue sky in the distance.

Then straight ahead lies the Inter Glacier and above it Mount Ruth, the Wedge; beyond that Steamboat Prow, and to the north Saint Elmo Pass at 7,415 feet. In the bowl beneath Burroughs Mountain to the northeast just beyond the pass, Alaska cedars are quite widespread, perhaps because of the heavy snowfall and moisture that collects above the basin.

Glacier lilies at Glacier Basin

Mount Rainier National Park's easternmost entrance, Chinook Pass is a destination in its own right, with many popular trails that weave in and out of the park boundaries. Highway 123, or the East Side Road, connects Mather Memorial Parkway at Cayuse Pass (below Chinook Pass) to US Highway 12 near Ohanapecosh. Construction began in 1931 and the road opened in 1940.

Heavy snow at the passes causes Mather Memorial Parkway to close at Silver Springs (north on Highway 410) each winter, but the road is often open by Memorial Day weekend, giving access to a Chinook Pass favorite: the Naches Peak Loop. The best time for the full 3.7-mile excursion into the high country (about 6,000 feet) is July and August as much of the trail is under snow until then. The short and fairly level hike is especially inviting for people with small children, or for those who have time for only a short visit to the alpine meadows. According to Tami Asars in *Day Hiking Mount Rainier*, hiking the loop clockwise is easier and offers the best views of Rainier. Wildflowers reach their peak in the summer months, but the beauty extends beyond flower season into the rich colors of autumn.

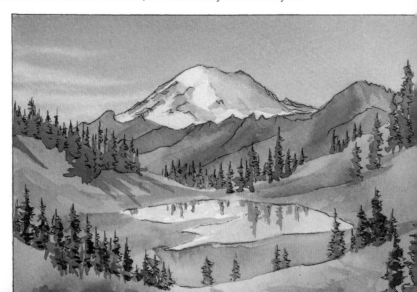

Tipsoo Lake and Mount Rainier near Chinook Pass

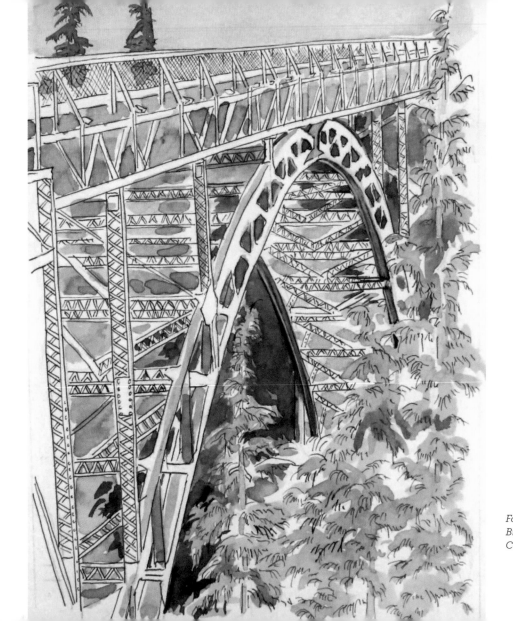

*Fairfax
Bridge,
Carbon River*

Carbon River & Mowich

The Carbon River is prime habitat for towering trees and quiet trails, while Mowich, seventeen miles farther up the road, is the starting point for popular Tolmie Peak Lookout and Spray Park.

Carbon River

The Carbon River area is in the northwest quadrant of the park, which is easily accessible from Seattle and Tacoma. According to Jim Hull, Carbon River Ranger, there are two types of visitors that come West. One comes for the forest and the peace and solitude. The second group comes for the mountain views and meadow wildflowers, and those visitors go up to Mowich Lake, Tolmie Peak, and Spray Park. Some families have been coming for generations for camping and backcountry trips. Many like to hike the lowland Carbon River portion of the Wonderland Trail, since, unlike other sections of the trail, it is mostly accessible during the winter months.

In the park's early days, Asahel Curtis, notable mountaineer and photographer of the Cascades, promoted the Carbon River area for just those reasons. His goal was to open up that sector of the park to greater tourism. In 1909 he led the third Mountaineers' club outing to Rainier. Seventy-five climbers joined him to ascend the mountain via the Winthrop and Emmons Glaciers.

The Carbon River area receives between seventy and ninety inches of precipitation each year and is the only inland temperate rain forest in Washington—by definition this type of forest

Townsend's chipmunk

receives at least fifty-five inches. The Carbon River Ranger Station, situated at 1,772 feet, offers entry to many of the lowland and higher elevation camps and hikes. There is a walk-in campground 5.1 miles up the now closed Carbon River Road at Ipsut Creek and an historic backcountry patrol cabin on the National Register of Historic Places. At 0.2 mile from the campground you reach the Wonderland Trail, which takes you to Mystic Lake and Moraine Park after crossing the suspension bridge over the Carbon River.

When I visited the Carbon River on a very rainy Wednesday in late January, vestiges of the heavy snow that had fallen in the previous week lay in low drifts alongside the road in a few places. The river was running wild below the Fairfax Bridge, which crosses the Carbon River three miles south of the town of Carbonado, outside the park entrance. The view of the dizzying drop to the river below has to be experienced on foot, so if you go, park your car, walk across, and be sure to look down.

The bridge was built in 1921 and employs a three-hinged braced steel arch. The elegant arched design prompted me to draw it, especially when I discovered that the Fairfax Bridge is only one of three such bridges still left in the state. In Europe bridge designers often chose the arch form because they were surrounded by them everywhere in the centuries-old Romanesque and Gothic architecture of their towns and cities, but in the United States, engineers were often content with simple spans and seemed to overlook the beauty of the arch. The bridge was added to the National Register of Historic Places in 1982.

Old man's beard lichen (*Usnea longissima*) grows only in the wettest places, and you know you've arrived at one of them at the Carbon River. As I approached the park entrance on Highway 165, huge big-leaf maple trees and alders were decorated with lichen banners, some of them as long as twenty feet. The ribbons and threads of old man's beard are creamy white; other shorter accompanying lichens are a gray green. The forest can take on a haunted look on such a winter day.

*Old man's beard
lichen, Carbon River*

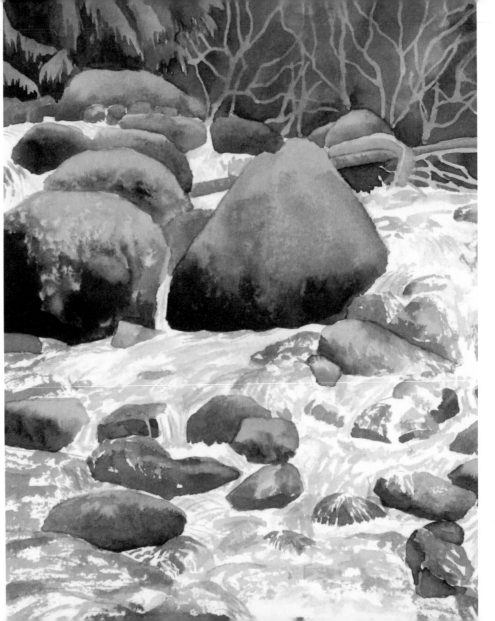

Tolmie Creek

In January these were the sounds: the roar of the Carbon River below me, the noisy rush of creeks tumbling into it, and the rain pattering on branches and the forest floor. If it is solitude you are after, this place generously offers it up to you. I stood beside a creek that wasn't identified either on the bridge that crossed it or anywhere nearby, but afterward I consulted a map and discovered it was Tolmie Creek. It rises near the head of Ranger Creek, north of Eunice Lake.

I admired the mossy lime-green boulders, tossed logs, and white water and thought how this entire world was dominated by water. Without the glaciers of Rainier high above and the winter rains, how could the towering ancient cedars and firs even exist? I thought of a few lines from Philip Larkin's poem "Water":

If I were called in
To construct a religion
I should make use of water.
Going to church
Would entail a fording.

The American dipper (*Cinclus mexicanus*) can be found along quickly moving streams, singing throughout the winter. Unlike most songbirds, it molts its feathers (like a duck) in late summer and is flight-less for a short time. It catches all its food underwater; if you observe this bird closely, you will be entertained for hours as it flies from rock to rock, even up waterfalls.

American dipper

Every time I see them, with their bouncing cheeriness, regardless of the weather, I have to stop and watch until my hiking companions get impatient.

The Steller's jay (*Cyanocitta stelleri*) is a forest dweller, and I associate it with lowland conifers, although I have seen it in the alpine meadows at Rainier. Its raucous cry is unmistakable, as is its striking blue plumage. A member of the corvid group, which includes crows, ravens, and magpies, it is very curious and intelligent, and often not at all shy.

Some of the biggest trees in the park are found along Ipsut Creek. In November 2019 we walked along the now closed Carbon River Road. Sketching my daughter and husband alongside the trees put the grand scale of the trees into convincing perspective.

During major flooding on the Carbon River in 2006, the river was eight feet higher than the road. The road sustained serious damage and the Park Service decided not to rebuild it. I hiked the Ipsut Creek Trail before the road was closed

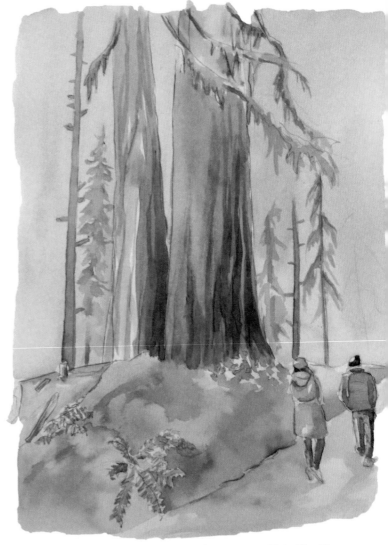

Carbon River Road hike (sketch)

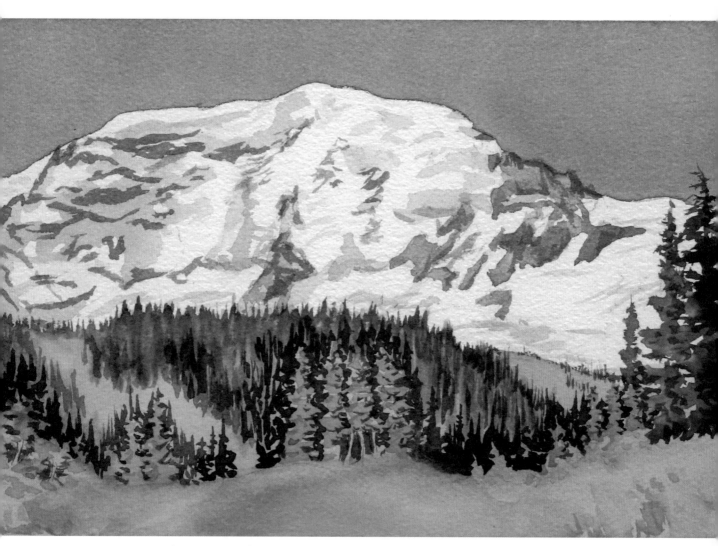

Mount Rainier from Moraine Park

and crossed the suspension bridge over the Carbon River at the snout of the Carbon Glacier, which hasn't retreated as much as the Nisqually Glacier, partly because its ice is so thick.

Farther along the Wonderland Trail above the Carbon Glacier snout, you come to Moraine Park, another of Rainier's subalpine meadows. The view you get of the mountain from this meadow (page 105) is formidable. To the left you see Curtis Ridge, and below it the imposing Willis Wall; left of center is Liberty Ridge and in the center is the equally fearsome Liberty Headwall. To the right is Ptarmigan Ridge. From this vantage point, the dangers of these features are minimized by the glistening snow and sunny blue skies, but many climbers have lost their lives attempting ascents via Liberty Ridge. Rockfall is common on these steep faces.

Mowich Lake

Mowich Lake, elevation 4,900 feet, is seventeen miles from the Carbon River Ranger Station on a 1950s-era gravel road. A ranger station and a popular walk-in campground are located along the shore of the lake. At 120 acres, the lake is the largest in the park and, at ninety feet, also the deepest. The area gives access to several beloved hikes, Spray Park being among my favorites.

Eunice Lake, northwest of Mowich Lake, was first called Tolmie Lake by Bailey Willis, who also named Tolmie Peak, in 1883, but the name was changed to honor Mrs. Eunice Gilstrap of Tacoma. Her husband was secretary of the Washington State Historical Society from 1907 to 1914. I sketched these trees as a way of honoring Abby Williams Hill, an early twentieth century Northwest painter who visited Rainier twice to sketch and paint (see page 112). She did a couple of very fine oil paintings in the vicinity of Mowich Lake.

Eunice Lake

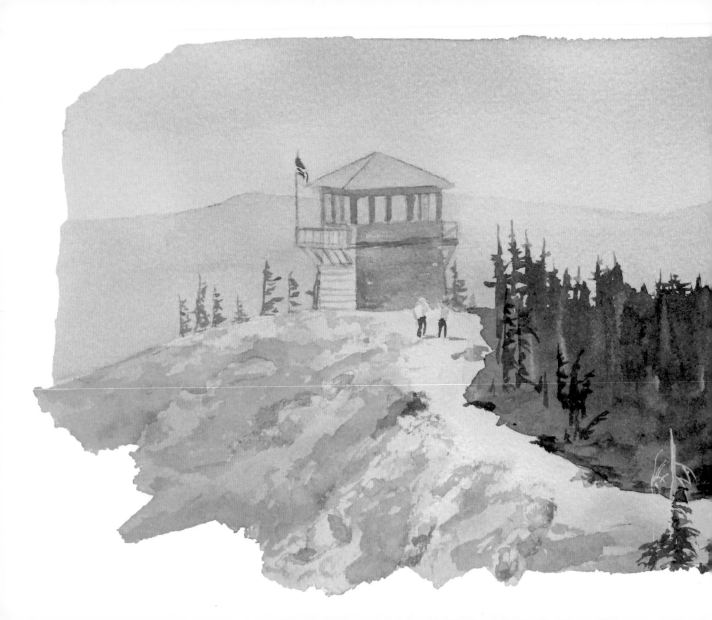

From Mowich Lake you can hike 3.2 miles to the Tolmie Peak Lookout. It is one of only four that remain in the park. The last few switchbacks are long and tiring. I was headed there a few years ago on an August hike with a good friend, but we had to give up just past Eunice Lake because we were being eaten alive by black flies. This sketch is from an earlier hike I did years ago with two friends. It is always a popular hike since it isn't too long and the views back to the mountain are wonderful.

The peak was named after William Fraser Tolmie (along with Tolmie Creek, which rushes toward the Carbon River thousands of feet below). Tolmie was thought to be the first non-Native to enter the area that is now the park, in 1833, when Mount Rainier was known primarily only to the Native peoples of Puget Sound and the Yakima area.

Tolmie, who had apprenticed with a well-known British botanist, was assigned as physician to the Hudson's Bay Company at Fort Nisqually, near Olympia. Hudson's Bay Company, chartered in 1670 by the British government, was for two hundred years mainly in the business of extracting furs from North America. They established numerous outposts in the Northwest. Of the doctors assigned there, David Douglas wrote, "These gentlemen have much to contend with. Science has few friends among a people whose only aim is gain on North West America." The doctors were undeterred in their noble efforts of collecting plants and studying the natural world. Tolmie set off on a "botanizing expedition" with Lahalet, the chief of a village near Fort Nisqually, and Nuckalkut and two other Native men who looked forward to hunting mountain goats and elk. Their approach was accompanied by heavy rain and clouds, but when they finally reached the heights, they saw the mountain.

Tolmie Peak Lookout

Tolmie wrote in his journal about the first approach:

The snow was spangled and sparkled brightly in the bright sunshine. It was crisp and only yielded a couple of inches to the pressure of feet in walking. Mount Rainier appeared surpassingly splendid and magnificent; it bore from the peak on which I stood, south southeast, and was separated from it only by a narrow glen, whose sides, however, were formed by inaccessible precipices.

It's a mere 3.5 miles on the Wonderland Trail to Spray Park from Mowich Lake. At 0.3 mile from the lake, you turn off on the Spray Park Trail. On the way up a short quarter-mile side trip on a spur trail leads to Spray Falls, a waterfall that drops 345 feet over andesite, a fine-grained igneous rock. Back on the Spray Park Trail, after several steep switchbacks you arrive at Spray Park, another of Rainier's subalpine wonderlands.

In high summer the meadows burst with flowers, beginning with avalanche lilies, then glacier lilies followed by spectacular displays of lupine and other midsummer blooms. In my painting lupine and the ubiquitous bistort (*Polygonum bistortoides*) punctuate the meadows with delicate staffs. A bit farther on and higher in elevation, but not easily distinguished from Spray Park, sits Seattle Park. It features many of the same species of flower, but in their alpine tundra forms they are miniaturized; they have adapted to the much harsher conditions.

Spray Park

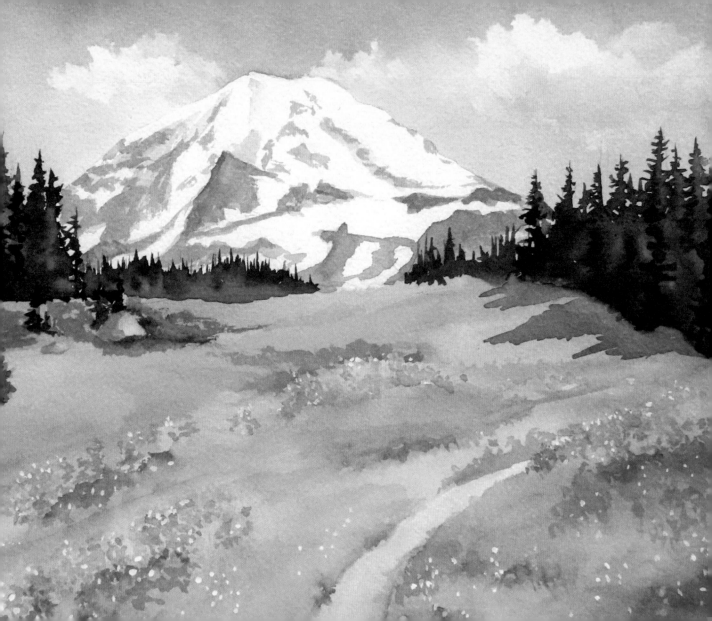

ABBY WILLIAMS HILL: CUT OUT FOR THE WILDS

Abby Williams Hill was an early twentieth century artist well-known for the work she did for the Northern Pacific Railway Company, exhibiting at expositions that helped drive tourism and migration to the West. After college she studied at the Art Students League in New York City. Later she and her husband moved to Tacoma, Washington, so she could explore and paint the state's wild places. Unfortunately, shortly after, her son was born partially paralyzed; for several years his care was her main concern.

In 1895, she determined to go to Mount Rainier. She once wrote about herself, "I was cut out for the wilds. . . . I cannot reconcile myself to spending on the stylish at the expense of the practical and good." In July she joined a twenty-six-day camping trip to Rainier, by that time already a very popular tourist destination, though it did not become a national park until 1899. It was a major undertaking to visit: She traveled by wagon to Longmire, then by packhorse to Camp of the Clouds, a base camp at present-day Paradise. Though her sketches from the trip are now lost, her journal entries remain, all of which convey her deep appreciation for her surroundings.

She wrote from somewhere above present-day Paradise,

> We pitched tent on an elevated place where the thunder of the avalanches on the Nisqually glacier came from the left and that of the

Sluiskin falls from the right. The night was bitter cold. All were quite ready to go home in the morning but me. I felt I could endure much for a few days of such grandeur.

The next morning she and a companion went to Sluiskin Falls, a four-mile walk with about 2,000 feet of elevation gain. She wrote that they soon came to the

> Paradise River, which dashes along at a wonderful speed over a bed of immense rocks. Sometimes a little lodged earth gives chance of growth and the result is a brilliant bed of flowers, nodding in the spray as gaily as if they were not ice-locked most of the year. . . . The rapidity with which these flowers bloom and fade is astonishing.

On commission from the Northern Pacific, Hill again traveled to Mount Rainier to create oil canvases for the 1905 Lewis and Clark Exposition in Portland, Oregon. She and her children traveled to Mowich Lake and then Eunice Lake. She set up a painting tent and kept it erected until she finished her canvases. Two of the paintings, *Basaltic Rocks* and *Cliffs at Eunice Lake*, are hanging at the First Presbyterian Church in Tacoma. *Mount Rainier from Eunice Lake* is in the collection of her works owned by the University of Puget Sound.

Of her painting site at Eunice Lake, Hill wrote,

> We camped on the bank of the lake, then moved to a ridge overlooking part of the Carbon valley and the meadows. . . . There were large banks nearby and the children spent happy hours sliding down them. . . . Back of the lake rises a high, rugged basaltic cliff and from the other side one has beautiful views with wild rocks and . . . firs for a foreground. Flowers abound and wild animal tracks but we have only seen whistlers.

There is so much to admire in Hill's life and work. She spoke up for equal rights for women and people of color. She advocated for conservation all her life. She adopted children, she cared for her disabled son, and later for her husband when he had mental health crises. All this in addition to her work as an artist, setting up outdoors in all weather, carrying all her oil painting gear, canvases, paints, and easel as well as tents and the camping supplies for herself and for her children, who often accompanied her. When I think of all the books about *men* and mountains, I think very few of those men could be compared with Hill, a woman who in strength, both physical and moral, truly matched the mountains.

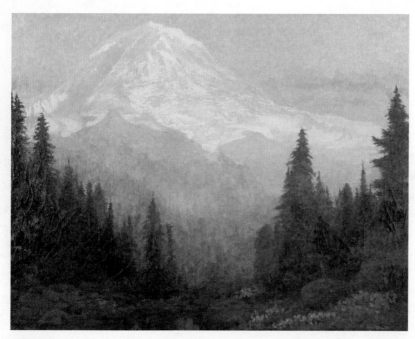

Abby Williams Hill, Mount Rainier from Eunice Lake, 1904, Oil on canvas, 27.5 × 34.625 inches, University of Puget Sound, photograph © University of Puget Sound

Wildflowers

The high-altitude flower meadows that encircle Mount Rainier have no equal anywhere on Earth. In *50 Best Wildflower Sites in the World*, Bob Gibbons captioned a photo of a Mount Rainier meadow, "The most flowery place in the world—the astonishing display of flowers at Mazama Ridge, Mount Rainier."

There are a couple of reasons for that. Especially at Paradise, the most luxuriant of all Rainier's alpine gardens, the meadows are in the perfect position to bear the brunt of the onshore flow of Pacific storms, since almost all weather systems there come in from the south and southwest, and secondly, the elevation is ideal for maximum snowfall and high moisture levels throughout the year, and most of the snow and rain fall at around 5,000 feet. Paradise is typified by a Sitka valerian (*Valeriana sitchensis*) and showy sedge (*Carex spectabilis*) meadow, alternating with heather woodlands. In fact, these high-elevation flowering communities occur all around the mountain, perched between rocky ridges above the deep glacial valleys.

The bloom and pollination time of each species can be very short, a few weeks at most. Pollinators tend to be attracted to certain colors. White flowers draw nocturnal moths and beetles, as well as butterflies and bees. Pink flowers attract butterflies and some moths. Yellow entices butterflies, bees, hoverflies, and wasps. Blue is especially compelling for bees because it's a color they can see. A few species are pollinated by hummingbirds—reddish or scarlet paintbrush, monkeyflower, red columbine, and Columbia lily (*Lilium columbianum*). We humans have cone receptors in our eyes for all the colors—perhaps so we can appreciate the wildflowers even more?

Tourists come from all over the world to see the wildflower meadows at Rainier. Unfortunately all this love results in much trampling. Rangers and volunteers have

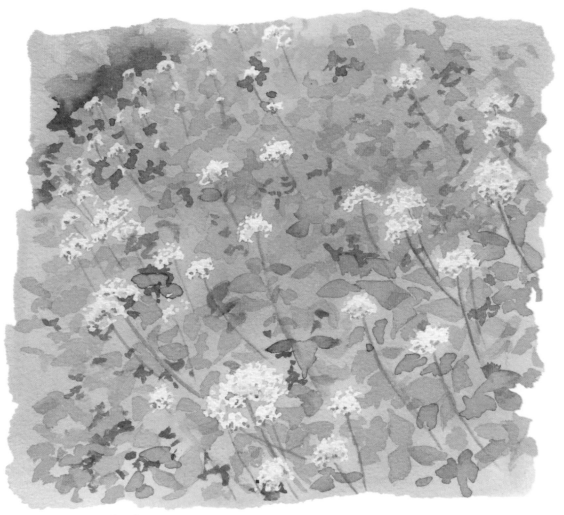

Sitka valerian

worked for decades identifying sites at risk, restoring them, and enlightening the public about the fragility of the meadows. I learned about one of these volunteers, Carolyn Knight, from my sister who lives in New Zealand. After working at Tongariro National Park in New Zealand, Carolyn came to Rainier in 1984 as a young woman through Volunteers-in-Parks, a program still in existence. One of her jobs that summer was to help identify the location of trails while they were still covered in snow because in their attempts to avoid walking on snow, visitors would tread on vulnerable plants. It was important—and a major undertaking—to shovel snow off the paths so people could walk on designated trails. Of her time at Rainier, she wrote that she was "in awe every day of the beauty and majesty of Mount Rainier, and was welcomed and inspired by the dedicated people who worked in the park."

In the last week of July I visited the meadows, which were snowbound quite late since it had been a heavy snow year and the weather in the Northwest stayed very cool throughout June and early July. At around 5,200 feet, thousands of avalanche lilies carpeted the meadows with pure white starry blooms. Among them were creamy western anemones in all stages of bloom. How strange it was to see emerging buds, newly opened flowers, and seedheads almost fully formed—all together like viewing a time-lapse video in real time. In these flower fields, time is compressed to a remarkable degree: it put me in mind of William Blake's famous lines:

To see the World in a Grain of Sand
And a Heaven in a Wild Flower
Hold infinity in the palm of your hand
And Eternity in an hour.

Sitka valerian (*Valeriana sitchensis*) poured down dizzying slopes of nearly forty-five-degree angles, their elegant stems holding aloft airy umbels of tiny white flowers. About 500 feet below, on roadside verges near the Lakes Trail, scarlet paintbrush and cobalt-hued lupine blazed together, a week ahead of those at higher elevations. I encountered a mat of cliff penstemon (*Penstemon rupicola*) in the gravel beside the road, with the color somewhere between opera pink and fuchsia—I use the names of a couple of my tube watercolors here because they best express the intensity of color. The mat must have been about three feet in circumference and other drivers were stopping to look at it. It was as compelling as a wild animal! Marveling at this explosion of color, I wondered at the same time: how could all these species be flowering simultaneously? Don't they resent the presence of other blooms? But the real threat is not other flowers, but trees. They are constantly shadowed by the legion of mountain hemlocks and subalpine firs waiting for the opportunity to advance and

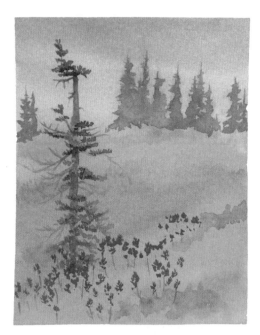

Paintbrush, in Paradise meadow

colonize the meadows. Warmer, drier conditions do not favor the flowers. In a recent warm period during the 1930s, trees advanced in several Paradise area meadows. Climate change is a real threat to the meadows.

One year I visited the Paradise meadows in August on an overcast day, but it only made the flower colors glow more intensely. I wrote these notes after I visited: *I have visited mountain heights and meadows in my mind countless times in all the enforced absences, work, travel, and caregiving. How odd in that gloom and grayness to feel such a benign presence—the chartreuse of the meadows, the dark spires of mature mountain hemlocks. And the scent—the terpenes of conifers—purifying, and glorious. These carbon/hydrogen molecules are the resin that protect the trees from herbivores, like bark beetles, and they also make the paint thinner turpentine. Terpenes released into the atmosphere may result in clouds that help cool the forest and the planet. Health-giving to an individual and to all species.*

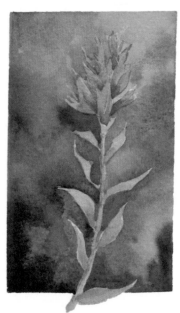

Magenta paintbrush

Mount Rainier is home to several species of paintbrush, which is one of the most widespread plants of subalpine meadows. The bracts, specialized leaves, rather than the flowers are colored. The scarlet paintbrush (*Castilleja miniata*) at Rainier occurs mostly above 5,000 feet but can occur as low as 2,800 feet on the Westside Road. Magenta paintbrush (*Castilleja parviflora*) also grows widely in subalpine meadows. In addition, brick-red cliff paintbrush (*Castilleja rupicola*) is common on cliffs and rocky slopes above 5,500 feet, mostly on the north and east side of the park. You can find them on the trail to Burroughs Mountain

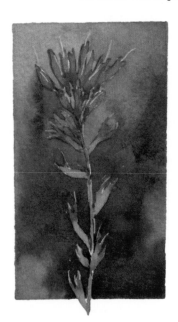

Scarlet paintbrush

near Sunrise and at Chinook Pass. Harsh paintbrush (*Castilleja hispida*) is a common lowland species found in dry, gravelly soil below about 4,000 feet. You will often see it on roadsides. Look along Westside Road at around 2,500 feet, and also at about 4,500 feet on Sunrise Road. The bracts of harsh paintbrush are most often scarlet but also can be yellow or orange.

The paintbrushes are "hemiparasites"; they gather nutrients from the roots of other plants. Bees and hummingbirds are the major pollinators of paintbrush, because the lack of a lower petal lip on the flower makes it impossible for other insects to perch.

The small white western anemone (*Anemone occidentalis*) or pasqueflower might be easily overlooked as you walk along a trail in early summer. It blooms after the snow has melted, following or simultaneous with avalanche lilies but preceding the high summer show of lupine and paintbrush, and is found in all the subalpine locations of the park. I was surprised to observe multiple plants in various stages of growth in one area, so I asked David Giblin and Donovan Tracy, authors of *Alpine Flowers of Mount Rainier* about that. They think the plants emerge and bloom at different times in relation to the snowmelt so one plant may be much more advanced than a plant nearby because its site became snow-free earlier. One individual may be in the shade of a tree where snow lingers, while another is exposed nearby on a sunny ridge. Once their short flowering period is over, the seed heads last two months—crucial for the seeds to take flight and disperse.

Western anemone

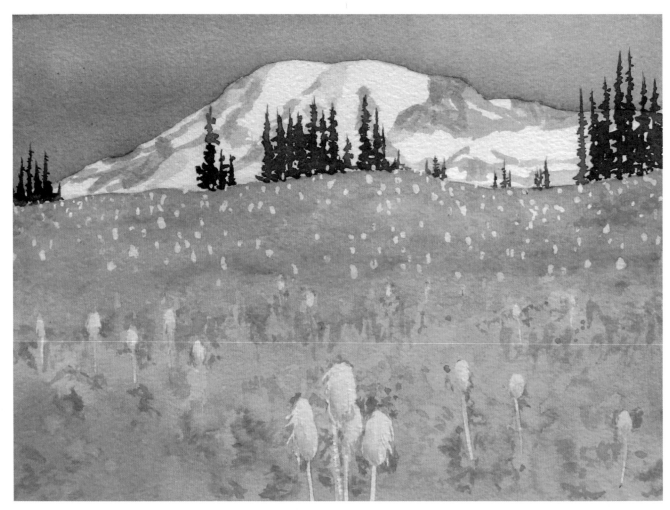

Mount Rainier and pasqueflowers from Mazama Ridge

There is no ignoring the pasqueflower's mop head that is created when the seed heads ripen. The plant had a powerful effect on people's imaginations even in the nineteenth century. In E. S. Ingraham's celebration of Rainier, which preceded the establishment of the park, *The Pacific Forest Reserve and Mount Rainier: A Souvenir*, early Washington State botanist C. V. Piper writes, "The curious seedhead of this western anemone is known by a number of nicknames including moptop, towhead baby, wind flower, and even 'old man of the mountain.'" He added, "The mountain anemone (*Anemone occidentalis*) always excited attention, their plumed heads reminding one irresistibly of the caps worn by grenadiers." A few decades later in *A Year in Paradise*, Floyd Schmoe described them as "troops of gray little monkeys."

More recently in *Wildflowers of Mount Rainier and the Cascades*, Mary A. Fries notes that the mop heads have been called "mouse on a stick." Other name: Fluff Puffs. How about the truffula trees, immortalized in Dr. Seuss's *The Lorax*? The list goes on!

In this watercolor of the view from Mazama Ridge, on the Skyline Ridge loop trail above Paradise, about a half mile downhill (south) from the Stevens–Van Trump Memorial, you can see how widespread the anemones are. Does it look as if the grenadier troops and the firs are advancing on the mountain?

Monkeyflowers of yellow and magenta cling to the edges of seeps and rivulets in massive displays that shade the contours of the swales like color blocks on a map. Seen from a distance the sight rivals any city garden's bed of annuals. I saw this lush plant in full bloom near Paradise on the Deadhorse Creek Trail as it winds westward to vistas of the Nisqually Glacier. Up to three feet tall, it is much larger than the yellow monkeyflower, but the flowers are roughly the same size, both enormous for the size of the plant. In *Wildflowers of Mount Rainier*, Laird Blackwell compares the colors of Lewis's monkeyflower at Rainier to the same plant in the Sierra Nevada. He says the hue at Rainier is "brighter and more vibrant, a touch more intense, a hue

deeper." My mother-in-law, an avid Chicago area gardener, commented on the intensity of flower colors in the Pacific Northwest. Plants adapt to seasonal temperatures by displaying deeper pigmentation; in their cooler and shorter bloom periods they must try even harder to attract pollinators. Other high-altitude adaptations include dwarfing, dish-shaped flowers, and hairiness, for warmth.

The mat-forming yellow monkeyflower (*Erythranthe tilingii*), rarely grows to more than a foot tall and can be found near streams at elevations from 5,000 to 11,000 feet. It often grows alongside Lewis's monkeyflower. I painted one that was growing among rocks above a creek. It is thought that the mosses among which the plant tends to grow help catch the seeds and then allow for the formation of large patches.

Lewis's monkeyflower

Subalpine meadows are full of daisies and asters, including the Cascade aster (*Eucephalus ledophyllus*), and the asters come in all the colors I painted—pink, lavender, blue, and even white. The variations occurred within a very small two-square-foot patch of meadow.

The flower of pale agoseris (*Agoseris glauca*) looks at first glance like a dandelion, but instead of the serrated leaves, it has grayish-green hairy leaves, the silver complementing its bright yellow flower heads like gem settings. I saw it along the Wonderland Trail above Sunrise.

Yellow monkeyflower

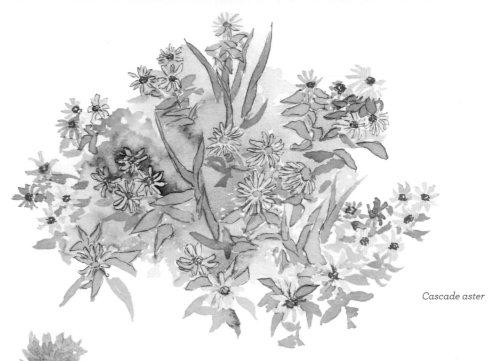

Cascade aster

Pale agoseris

Glacier lilies (*Erythronium grandiflorum*) bloom after the avalanche lilies and are not as widespread. The plant is slightly smaller than the avalanche lily and the tepals curl back with yellow stamens and longer branched stigma. Bears and other wild creatures feed on all parts of the glacier lilies in spring, especially the bulb, or corm. These flowers were among many wildflower specimens collected by Lewis and Clark.

Lavish wildflower meadows on the mountain are not limited to Paradise. Spectacular displays occur each year in all the high-elevation meadows that surround Rainier,

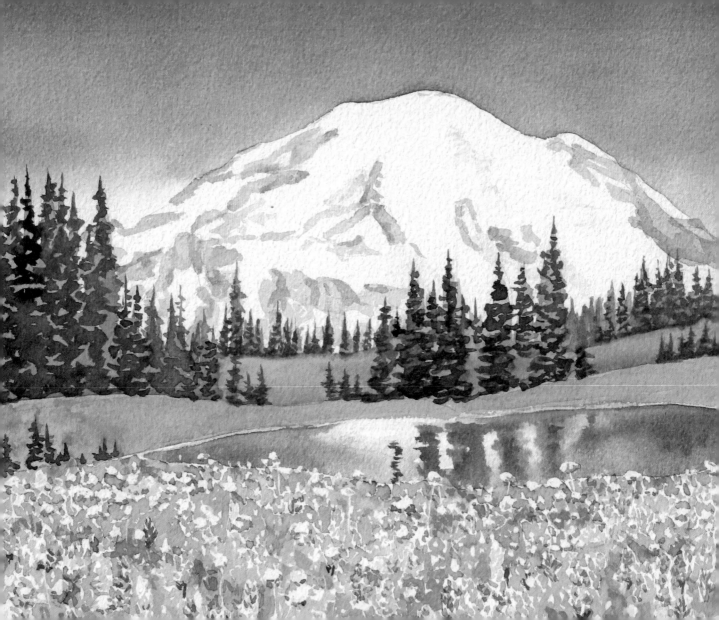

but the time of the display varies depending on snowpack which in turn differs by location. Even though it is on the east side, Chinook Pass (5,500 feet) is high enough to receive a very generous share of moisture.

British author Richard Mabey wrote that the meadows of Rainier were like a "real scene that could have come from a Medieval Book of Hours," those hand-painted, colorful prayer books owned by everyone from wealthy aristocrats to servants. The calligraphed pages of psalms and other prayers were decorated with gilded letters, rubricated capitals, delicate traceries of colorful flowers and plants, and sometimes even tiny landscapes and scenes. The meadow I painted at Tipsoo Lake looked so much like an illuminated page of a Book of Hours. Mount Rainier was like the white page of one of those devotional texts, ornamented in blue lupines, magenta paintbrushes, and sparkling white valerians, bistorts, and anemones.

Glacier lilies

Tipsoo Lake and Mount Rainier

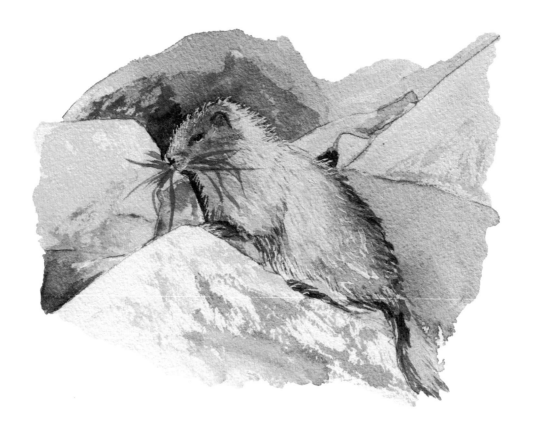

Hoary marmot

Acknowledgments

Heartfelt thanks go to:

My agent, Anne Depue, for her steady support and inspiration through three books.

Kate Rogers, editor in chief of Mountaineers Books, for welcoming my ideas, kindling further ones with her own, and helping me develop the structure and focus of this and two previous books.

My hiking companions: David, Tom, Rose, Jane, Julie, Mich, Gerry, Dave, Anne, Mary, and Pat.

For reading drafts and offering endless advice and suggestions: Rose Hashimoto, Tom Hashimoto, Ilona Popper, David Lord, Patrick Friel, Susan Hamilton, Kelvin Bates, Sally Yeager, and Nick O'Connell.

Editors: Kirsten Colton, for insightful reading and wonderful suggestions, Ellen Wheat, for close attention and excellent ideas (especially about color!), and Mary Metz, reader extraordinaire and advisor.

Book design: Kate Basart for her always beautiful ideas.

For sharing their photos: Glenn Dreger, Dennis Kitto, David Lord, Beverly Choltco-Devlin, Jolane Stroh, and Mary Snadoff.

Katie and Tom Burke of Pomegranate Communications, who have published my art for decades, and to the rest of their talented staff.

Curators, historians, scientists, and collection managers: Jeff Bradley, collection manager of mammals, Burke Museum; David Giblin and Donovan Tracy, authors of *Flowers of Mount Rainier National Park*; Elizabeth Fallon, Mount Rainier botanist; Dr. Keith Aubry, biologist emeritus for the US Forest Service, Washington, DC; Dr. Jocelyn Akins, conservation director, Cascades Carnivore Project.

Jim Hull, park ranger at Carbon River, and all the rangers at Mount Rainier National Park.

Rick Johnson and Jana Gardiner of Ashford Creek Gallery, Mount Rainier, who answered many questions and shared the books, postcards, and art in their museum and facilitated access to Dee Molenaar's painting.

Karen Molenaar Terrell, daughter of Dee Molenaar, for permission to reprint his painting.

Sunny Thompson of Wellspring Spa and Resort, Ashford, Washington for providing respite and comfort.

For support in trying times: Sue Prescott, Carin Mack, and Maggie Pheasant.

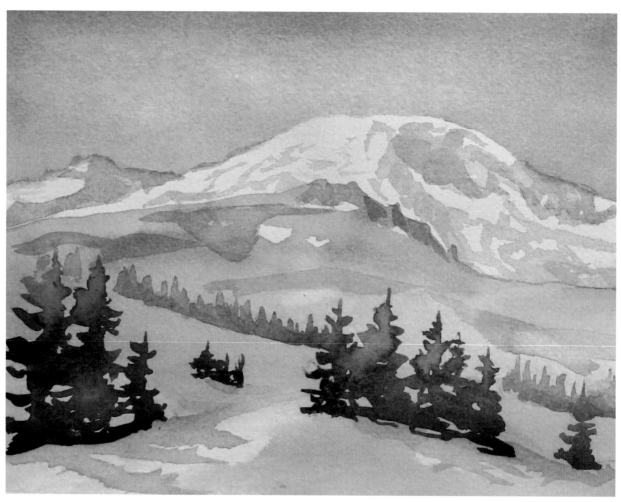

Wonderland Trail near Berkeley Park

Resources

MOUNT RAINIER NATIONAL PARK
55210 238th Avenue East
Ashford, WA 98304
360-569-2211
www.nps.gov/mora

Visitor Centers

LONGMIRE MUSEUM
360-569-6575

HENRY M. JACKSON MEMORIAL VISITOR CENTER AT PARADISE
360-569-6571

OHANAPECOSH VISITOR CENTER
360-569-6581

SUNRISE VISITOR CENTER
360-663-2425

Camping & Lodging

FRONTCOUNTRY CAMPGROUND RESERVATIONS
www.recreation.gov

IN-PARK LODGING RESERVATIONS
www.mtrainierguestservices.com

Wildflower Guide
www.nps.gov/mora/learn/nature/wildflowers.htm

Further Reading

Alden, Peter. *National Audubon Society Field Guide to the Pacific Northwest*. New York: Alfred A. Knopf, 2013.

Asars, Tami. *Day Hiking Mount Rainier*. Seattle: Mountaineers Books, 2018.

Blackwell, Laird. *Wildflowers of Mount Rainier*. Edmonton, AB: Lone Pine, 2000.

Catton, Theodore. *National Park, City Playground: Mount Rainier in the Twentieth Century*. Seattle: University of Washington Press, 2006.

Franklin, Jerry F. *The Forest Communities of Mount Rainier National Park*. Washington, DC: Scientific Monograph Series No. 19. National Park Service, Department of the Interior, 1988.

Fries, Mary A. *Wildflowers of Mount Rainier and the Cascades*. Seattle: Mountaineers Books, 1970.

Harmon, Kitty, ed. *The Pacific Northwest Landscape: A Painted History*. Seattle: Sasquatch Books, 2001.

Johnstone, Donald. *Mount Rainier National Park*. Charleston, SC: Arcadia Publishing, 2013.

Kirk, Ruth. *Sunrise to Paradise: The Story of Mount Rainier National Park*. Seattle: University of Washington Press, 1999.

Molenaar, Dee. *The Challenge of Rainier: A Record of the Explorations and Ascents, Triumphs and Tragedies on the Northwest's Greatest Mountain*. Seattle: Mountaineers Books, 1979.

Nadeau, Gene. *Highway to Paradise: A Pictorial History of the Roadway to Mount Rainier*. Puyallup, WA: Valley Press, 1983.

Pojar, Jim, and Andy MacKinnon. *Alpine Plants of the Northwest: Wyoming to Alaska*. Edmonton, AB: Lone Pine, 2013.

Pyle, Robert Michael, and Caitlin C. LaBar. *Butterflies of the Pacific Northwest*. Portland, OR: Timber Press, 2018.

Schmoe, Floyd. *A Year in Paradise*. Seattle: Mountaineers Books, 1999.

Smith, Allan H. *Takhoma: Ethnography of Mount Rainier National Park*. Pullman, WA: Washington State University Press, 2008.

Taylor, Ronald, and George Douglas. *Mountain Plants of the Pacific Northwest*. Missoula, MT: Mountain Press, 1995.

Tracy, Donovan, and David Giblin. *Alpine Flowers of Mount Rainier*, third edition. Seattle: University of Washington Herbarium, Burke Museum, 2018.

Whitney, Stephen, and Rob Sandelin. *Field Guide to the Cascades and Olympics*. Seattle: Mountaineers Books, 2003.

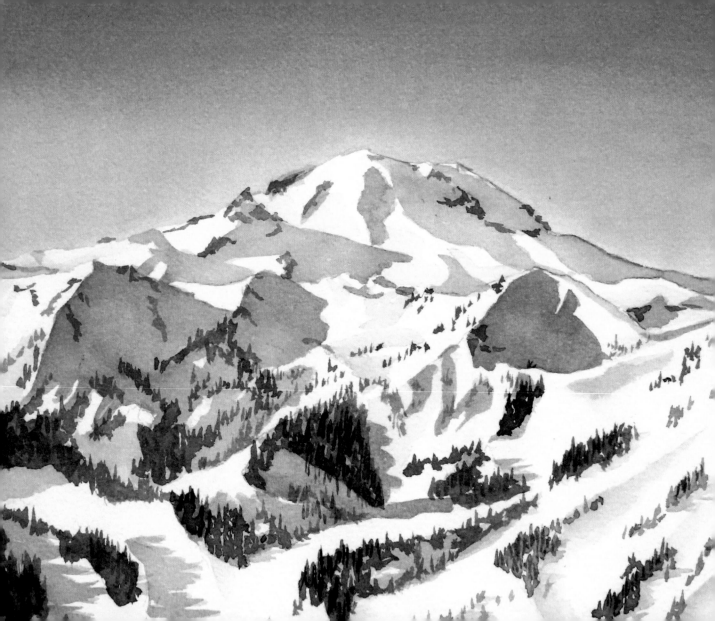

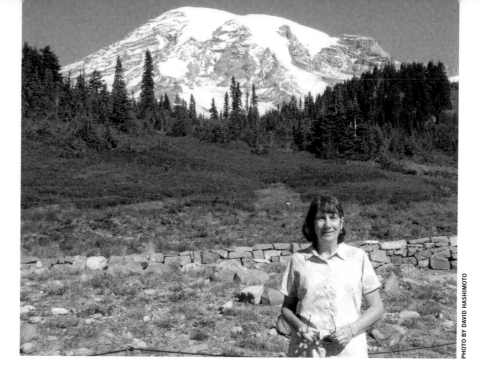

About the Author

Molly Hashimoto explores parks and wildlife refuges all over the West, seeking inspiration for her sketches, paintings, and prints. Her work has appeared for thirty years on cards and calendars published by Pomegranate Communications, and she is the author and artist of *Colors of the West* and *Birds of the West*.

Dedicated to connecting people to nature through hands-on art experiences, Molly teaches aspiring artists and and leads plein air workshops throughout the West, including at the North Cascades Institute, Yellowstone Forever Institute, Yosemite Conservancy, and Sitka Center for Art and Ecology. She lives in Seattle.

SKIPSTONE guides explore healthy lifestyles, backyard activism, and how an outdoor life relates to the well-being of our planet. Sustainable foods and gardens; healthful living; realistic and doable conservation at home; modern aspirations for community—Skipstone tries to address such topics in ways that emphasize active living, local and grassroots practices, and a small footprint. Our hope is that Skipstone books will inspire you to celebrate the freedom and generosity of a life outdoors.

All of our publications, as part of our 501(c)(3) nonprofit program, are made possible through the generosity of donors and through sales of 700 titles on outdoor recreation, sustainable lifestyle, and conservation. To donate, purchase books, or learn more, visit us online:

www.skipstonebooks.org | www.mountaineersbooks.org

SKIPSTONE

LIVE LIFE

MAKE RIPPLES

YOU MAY ALSO ENJOY:

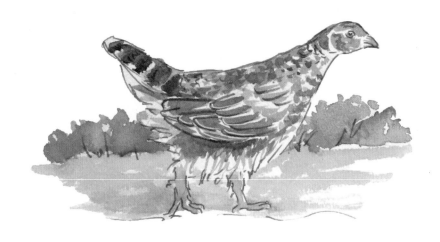